PROFESSIONAL
Digital Portrait
Photography

Jeff Smith

AMHERST MEDIA, INC. ▪ BUFFALO, NY

W9-BGA-632

Published by:
Amherst Media, Inc.
P.O. Box 586
Buffalo, N.Y. 14226
Fax: 716-874-4508
www.AmherstMedia.com

Publisher: Craig Alesse
Senior Editor/Production Manager: Michelle Perkins
Assistant Editor: Barbara A. Lynch-Johnt
Proofreader: Donna Longenecker

ISBN: 1-58428-089-1
Library of Congress Control Number: 2002103401

Printed in Korea.
10 9 8 7 6 5 4 3 2 1

CONTENTS

DIGITAL PHOTOGRAPHY

*P*hotography is changing, or is it? Whether we use a brand-new digital camera or a cherished film camera, we use a piece of equipment to capture an image of a client that we hope they'll like. They place an order for prints of our images, but we still own the copyright to them. They pay us money, we pay our bills—and hopefully have a big pile of money left over every month to invest! When you think of the new technology in these terms it really doesn't seem like a big deal. Some photographers think this is a scary time. Why? A camera records an image. Does it matter whether that image is captured on film or on a digital capture chip? Of course not! The stress that many photographers feel about changing to digital is unfounded.

Digital capture was put into perspective for me during a convention dinner. My wife and I were sitting at a table with some of the photographers who'd given presentations at the convention. There was one family who'd been in business for years. In

Capturing digital images for my web site, brochures, fast candids for our schools or for quick portraits that would be impossible with film makes digital a viable choice. In each use there is a significant savings in time/money or, for time-consuming "specialty" jobs, a client who is willing to pay an extra fee to offset additional costs.

fact, they were in their third generation in the business. Their son, who was in his late thirties, had taken their studio digital. As the photographers around the table were talking about digital, the father, who was in his fifties/early sixties remembered the shift from black and white to color. He said that some photographers saw opportunity, some photographers were scared to death and some said it was just a passing phase and that images *should* be captured in black and white.

This is the same reaction that photographers are having to digital today. Some are scared. I've heard some photographers say that when Kodak produces that last roll of medium format film, they'll switch to Fuji; when Fuji produces the last roll of film, they'll switch to Agfa, and then they'll move on down the line.

On the opposite end of the spectrum are all the speakers and digital equipment companies (who sponsor those speakers) making profound, albeit ridiculous statements like, "Anyone who isn't in digital in the next five years won't be in business." These guys are just like the people who predicted flying cars to the children of my generation! Well, flying cars are still a few years from being commonplace, and so is 100 percent conversion to digital in this industry.

Somewhere in the middle are people like me (and probably you) who see potential in digital, but are cautiously optimistic. I know that some photographers who have read my articles on digital think that I am a die-hard film guy, but that isn't true. I use digital—I have been using it for years—when it makes sense to do so. I have found that capturing digital images for my web site, brochures/booklets, fast candids for our schools or for quick portraits that would be impossible with film makes digital a viable choice. In each use there is a significant savings in time/money or, for time-consuming "specialty" jobs, a client who is willing to pay an extra fee to offset additional costs. I call myself a digital realist.

In gathering information to see if digital was right for my studios, I kept running into the same people giving me advice. Either they were speakers with "infomercials" about the latest $20,000 digital camera back or photographers who'd just entered into digital and were still suffering from what I call the "digital glow." (Digital glow is the starry-eyed look that people who have just gone into digital suffer from. It's similar to the expression you see on the face of a guy who has just bought a Mercedes/Porshe. This condition usually lasts right up until the first payment comes due and reality sets in—you've just gone into serious debt for an item that depreciates quickly!)

Some photographers who have read my articles on digital think I am a die-hard film guy, but that isn't true.

Everything has some drawbacks; you just have to wait until the rewards outweigh the possible problems, then give it a try.

This book covers the pros and cons of going digital. Digital is an option for some photographers, but it isn't right for everyone at this point in time. My goal is to help you determine whether or not now is the right time for you.

When I decided to write this book, I did so because I wanted to give photographers a realistic view of working with digital. I wanted to be completely honest about the work involved in converting a working studio from film to digital. Digital has amazing creative potential, and it allows photographers to go from the session to the final prints in one day. It also has its drawbacks, as all new technology does. You have the Internet in your home. It gives you and your children access to a world of information, but it brings with it the possibility of exposing your children to many things they shouldn't be exposed to. Everything has some drawbacks; you just have to wait until the rewards outweigh the possible problems, then give it a try.

Photographers entering into digital often get so caught up in the hype and possibilities, they don't consider the fact that capturing an image in a session is actually only a small part of their entire business system. Careful management of the business system—which includes image capture (on film or digital), the processing of the image, the delivery of the photographs to the client and absolutely every aspect of managing your business, from advertising to controlling your costs—is critical. You see, there are many steps involved in the business system. Unfortunately, many photographers get excited about digital cameras and backs and what can be done with Adobe® Photoshop®, but never stop to think about how these changes will impact their business.

When professional speakers and the manufacturers of digital equipment sell the benefits of going digital, they don't spend a great deal of time talking about the business system. They don't let on that digital will completely affect every aspect of your business. For example, for years, photographers have been trying to work their way out of the darkroom. They let the lab take care of everything but simple packaging and negative storage, and concentrate on what they are good at and what makes the most money: photographing clients! Yet many photographers find that once they switch to digital, they are spending much more of their productive shooting time using their virtual darkroom—the computer.

Digital will entirely change the way you handle your images. You will no longer collect your film at the end of the day and send it off to someone else to handle it. You will have to capture, process, save,

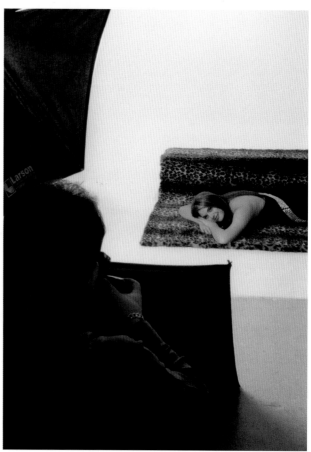

store and package for the lab each file you create. You will need to manage a retrieval system that will allow you to quickly access all the CDs that you'll be burning every day.

In addition to the changes in your business system, there will be changes in the way you photograph. If you are like the average portrait photographer, you've used negative film for years, have gotten sloppy with exposure and probably haven't shot slide film in a long time. Shooting digital is just like shooting on chrome film—it isn't very forgiving. You capture the image the way you want it. You don't take it any old way and let your lab print out all the problems. Color casts show in the final images. You must become familiar with the words "white balance" (an important concept that we'll cover in chapter 2). Most importantly, you can't overexpose anything. When you blow out a white background on film, you may have a little glow around the subject, but do it on digital and you have a mess, usually a cyan/white mess.

Another consideration is the cost of buying, learning to use and upgrading and maintaining all of this expensive equipment. When you buy a well-regarded new film camera like a Hasselblad, you make a serious investment in your business. That camera will provide you

One of the benefits of shooting digitally is that you can immediately see your image right after firing the camera. This allows you to make subtle changes to the pose, lighting, etc.

with years of service and will retain some value down the road for trade-in purposes. You won't see your $4,000 dollar camera advertised for $1,999 a year after you purchased it. Kodak and Fuji won't change film sizes after four or five years and tell you that you have a dinosaur that they just don't make film to fit anymore.

● *Weighing the Costs*

Planned obsolescence is a reality with new technology. Your new computer quickly goes from being the hottest model to a relic that you have to sell in the classifieds for $100. I see people throwing down their credit cards or signing up for financing to buy a new computer system, despite the fact that they won't get 30 percent of that computer paid for before they have to buy another. Things are changing quickly in digital; unless that special new piece of equipment is going to help you turn out a fantastic profit, you're simply going to wind up in the hole. If your film cameras are paid for, you're making a great living and you don't think that going digital will help you to increase your profits, why on earth would you change to digital capture now?

There are many myths about digital. The first and most incorrect one is savings on film. Many photographers think the money they used to spend on film will cover the bill for the new digital camera, the larger staff to handle all the files created in the studio and all the new equipment that will need to be upgraded regularly. Well, I don't know what kind of film these photographers are using, but there is no way the savings on film is going to come close to covering all those expenses. As a matter of fact, most photographers who shoot digital (who aren't still suffering from the digital glow) will freely admit that shooting, filing and storing the media (when you figure in the cost of the time involved) is more expensive than the film and processing involved with shooting film.

Now you realize why some photographers think I am a film guy! Well, I'm not a film guy or a digital guy; I am a businessperson. If I am going to spend one dollar to upgrade my equipment or replace something I already have, I want to see the potential to make that dollar back many times over. Many photographers are like kids in a candy store when it comes to equipment. They buy toys, not tools, and they buy them impulsively.

A digital camera is the ultimate toy for a photographer. Using a professional-quality digital camera is the most fun experience I have had since I got started in photography. You see what you create

There are many myths about digital. The first and most incorrect one is savings on film.

immediately. It's easy to correct imperfections and add special effects and graphics to your images. With digital, you work with a small camera that you can handhold, not a monster medium format camera rolling around on an eight-foot camera stand. I love it!

Once a photographer picks up a digital camera and uses it, he or she is hooked, and simply will not be content until they start using one. This is why you should know what you're getting into. There are many ways to make digital work for you. You can create additional profit to pay for the costs of converting to digital capture, but no one talks about that. Again, no one talks about it, because it isn't as easy as most people assume, and your savings on film *definitely* won't pay for it all!

While many photographers can't wait to move to digital, others don't even allow themselves to think about digital. If you've decided that digital isn't for you right now and you've based this on profit, that's fine. But if you've decided that digital will never be right for you, you have a problem. Photographers who refuse to consider digital are very much like those who refuse to use a computer for invoicing, despite the savings in time. The photography that these folks produce doesn't change much over the years, or even decades. They just don't roll with the changes.

Many photographers suffer from fear of change. In most cities you see businesses that time forgot. They still have 1970s décor, and you get the feeling that Barnaby Jones might walk out the door any minute. Even though most businesses left the area long ago, headed for greener pastures, these business owners don't want to pay more for rent. For some, the building is finally paid for, and they think that staying put is the smartest option—who cares if there are hookers walking back and forth in front of their building? They are scared to leave what is familiar.

● *Confronting Change*
It's easy for people to keep doing exactly what they've always done, but to be successful, you can't. You have to look at new opportunities. When there is a new way of doing things, you have to take advantage of it *if* it allows you to provide a better product, more convenient service for your clients or a greater profit potential. Whether it's color film over black and white, offering your clients new ideas, moving to a new studio (or renovating the old one) or capturing images on film or digitally, successful people learn not to fear change, but to look for the opportunity in it.

Once a photographer picks up a digital camera and uses it, he or she is hooked, and simply will not be content until they start using one.

Whether you're scared to go digital or are suffering from the digital glow and trying to establish a working business system, this book will help you to make educated decisions—decisions that are based on realistic information, not on fear or the lofty notions of the folks that prophesied the flying car.

As you read this book, keep in mind that, with the lightning-fast changes that constantly affect all technologies, brands and models become obsolete or outdated quickly. With that in mind, I have tried to present generalized information that will help you to develop a working business system—*without* going into specific brands or models.

THE DIGITAL CAMERA

*A*bout five years ago, my lab told me that anyone who wasn't using digital with seniors would be out of business in five years. Since high school seniors are all we do, I was a little concerned. I thought it was once again time to look into the cameras and backs that were being offered. I called around and, at that time, the largest print any 35mm style digital camera could create was 8x10 inches. I was told I needed a $15,000 digital back to produce anything with photographic quality in a larger size.

This $15,000 "wonder back" would allow me to print out images up to 11x14 inches in size. I explained to the salesperson that we sell many 16x20-inch prints. Of course, they had a back for $25,000 that would go up to a 16x20, but nothing that would produce a 20x24 (now remember, this was five years ago!). We have two studios, so I'd need seven of these backs for all the shooting areas and photographers I have. That's a whole lot of money! At that point, I realized that it might be

more than five years before all the senior photographers went digital. Those "prophets" of the flying car were a little off in their predictions again.

Many photographers feel (as I did at that point) that if they don't jump on board the technology train, they'll be left at the station. While I wouldn't want to be stuck at that station in ten years (it may be a lonely place), you shouldn't feel pressured to switch from film to digital. When you make the transition, you should do so because you can increase your profit, not because you're afraid to fall behind. Let's be honest—even today, digital cameras are much more expensive than film cameras, and many photographers simply can't afford to make the transition.

After years of using a medium format camera and large studio camera stand, handholding a camera can be very liberating.

Let us look at digital cameras from a business perspective. If I'd bought those seven digital backs five years ago, I'd still owe a bundle of money on equipment that would be practically worthless in today's market. At that time I didn't see how I was going to make up that $175,000 before the backs became obsolete—that's what my hesitation to make the switch came down to.

I don't care how far digital cameras have come or how many photographers are using them. Until you see a way to pay for those cameras through additional profit, *don't* switch from film. This isn't a race. There are photographers making a great living using outdated equipment. I know one photographer who has his own lab, and I think half of his processors are held together with rubber bands and duct tape. That lab is paid for and until it breathes its last breath, he will keep patching it up and profiting from its use.

When it comes to technology, everyone wants to be a pioneer. However, being first isn't always the best place to be in business. By waiting to convert to a new technology, the transition is made easier. (I'm not talking about twenty years here; just wait until you feel it's right for your business.) The quality of digital equipment and software—and the knowledge of those who use it—is much greater than it was just a few years ago. When you step out of the race, you let others pay more for their equipment and fund the research for the new versions that users like you and I will buy. It's the pioneers who struggle to come up with ways to make everything work, and by waiting long enough you can learn from their mistakes, rather than making them all yourself.

● *Camera Selection*

I realize that for some of you this is Digital Camera 101, but we have to start somewhere. When selecting a camera, there are many factors to consider—you have to determine which type best suits your needs as an artist and businessperson. As I said before, I look at cameras as tools, not toys.

With film cameras, you have to consider the format of film the camera uses. The larger the format, the more expensive the camera *and* the larger the size of the final image you can produce (larger negatives can produce larger prints). Many young photographers just starting out feel it's necessary to use a medium format camera system, although the largest print they offer is an 11x14 and they can barely afford the 35mm they currently use. If a 35mm does the job effectively, from a business standpoint, why would you want to spend

the extra money for a camera system you really don't need? Do you think a beautiful 11x14-inch image created with a Hasselblad would be any less beautiful if it were created with a 35mm? I don't think so!

Skill is more important than the type of camera you use to capture your images. You can put the most expensive camera in the world in the hands of a person who isn't skilled and you'll still have disappointing photos. Expensive cameras cannot compensate for a lack of skill, though many younger photographers starting out seem to think so. Young photographers should buy only the equipment they truly need, and invest the rest in education. Buying books, tapes and spending time practicing is a much better idea than pricing equipment in photography magazines. After all, it's the photographer who composes great images, not the camera.

Skill is more important than the type of camera you use to capture your images.

⊙ Camera or Digital Back?

Your options for digital capture are the 35mm-style camera or the digital back, which attaches to a variety of medium format cameras. Both have advantages and disadvantages, but your decision should ultimately be based on your business needs. If you need to produce huge prints (over 24x30 inches) you'll have to use a digital back. At this point, the best 35mm-style digital camera will not produce portraits over this size—and many of them won't even come close to producing a 24x30-inch print!

One of the benefits of selecting a 35mm-style camera is ease of operation. There's nothing more liberating than handholding a camera during a session after being tied down to a medium format camera and large camera stand for years. Usually the 35mm-style camera is less expensive because you need to buy only a single piece of equipment. In contrast, when you decide to shoot with a digital back, you need to purchase the digital back and the medium format camera system. Again, the equipment you select for your studio must suit your specific needs.

Digital Capture Chips. In film photography, images made on Ektachome slide film do not look exactly like those made on Kodachrome or Fujichrome. Each slide film has certain characteristics that produce a unique look. It's your duty to select the film that produces the type of images that look best to you. The same is true of the digital chips in cameras. Each camera records an image slightly differently; you have to look at the way each brand you're interested in records an image. There are two types of digital capture chips, and each has its uses.

CCD. In the past, CCD (charge coupled device) chips, not CMOS chips, were used in high-quality digital cameras and backs. They offered a better dynamic (tonal) range, were more light-sensitive and produced less noise than CMOS. Today, however, CMOS are also used in high-end cameras and digital backs. CCD chips are manufactured in a highly specialized way—therefore, the cost of the chips and the cameras that contain them can be quite expensive.

CMOS. As mentioned above, the CMOS (complementary metal oxide semi-conductor) chip is more widely used than it was in the past. This chip has its advantages: it is cheaper to produce, smaller in size, uses less energy and is longer-lasting. It also allows more control over the the adverse effects caused by overexposure. With CCD

Time is Money

Many photographers think they can fix any and all problems with color or contrast in Photoshop. While Photoshop can correct many problems, you have to remember that in business, time is money. If there are two cameras that are the same in every way, except that one produces a skin tone that you consider perfect and the other is lacking contrast and too yellow for your taste, which one should you select? Adding contrast and blue (to compensate for the yellow) is easy to do in Photoshop, but how much time will that take? When you multiply the time it takes to apply a digital fix by the thousands of images the average studio shoots in a month, you'll find that you have a great deal of time you must pay for, in one form or another.

chips, the photographer must be careful to tightly control the lighting in the highlight areas to avoid image degradation; with CMOS, the photographer can use lighting just as it is used with film.

The size and quality of the chip determine the quality of the images you will be able to create. Most popular cameras contain chip sizes that range from 2.74 to 5.47MB. Keep in mind that as the CCD chip size increases, the price of the camera will, too. Of course, the resulting quality is a great trade-off.

With the release of the Canon D30, the Fuji S-1 and the Nikon D-1, our lab ran tests on the files from each camera. Every camera used a different type of chip to record the image. The Canon used a CMOS chip, the Fuji used a "Super CCD" chip and the Nikon used a standard CCD chip. While this means nothing to the average photographer, it did make a difference in the performance of the cameras. With the different types of chips, each camera produced a different file size. It also turned out that the D30 produced a file that could be enlarged more than the other two, although its file size was not the largest.

When a company tells you their "wonder back" or "super camera" produces a 20MB file, you have to see what that 20MB file produces. To add to the confusion about file size, many cameras can capture a raw TIFF file, producing an inherently larger file size than the same image as a JPEG. But in most cameras, this is a 16-bit image. Photoshop, as well as most printers, can't handle a 16-bit image (at this time), so you must convert each image to an 8-bit file, disregarding the additional information.

There are other factors that should be considered when selecting a camera as well. They are:

1. Burst Rate—This term refers to the time it takes for a camera to capture and process information. Higher-end cameras have faster burst rates than less expensive ones.
2. Sensitivity/ISO Range—With digital cameras, a change in light sensitivity is possible at any point during your shoot. Select a camera with an ISO range that suits your needs.
3. Shutter Response Time—How long does it take for the camera to fire once you press the shutter button? (This will impact the burst rate.)
4. LCD Panel—Your images can be easily previewed on the LCD screen. When shopping for a camera, make sure that you can clearly see the image.

The size and quality of the chip determine the quality of the images you will be able to create.

Left (100 ISO) and Right (1600 ISO): Digital cameras can be set from 400–1600 ISO. In low-light outdoor scenes, however, the quality of the image suffers—high speed medium format film produces better results.

5. Lens Capability and Accessories—As with a film camera, it's important to consider whether or not lenses you like and accessories you use regularly are available for your camera.

6. Color Depth/Bit Depth—This directly affects image quality. Simply put, the more bit depth you have, the more color information there is. A 16-bit image represents millions of colors. An 8-bit depth, on the other hand, produces significantly less depth, and therefore, lower image quality.

7. Memory Card/PC Card—Through these cards, images can be stored and transferred to your computer for retouching, storage, etc. Compare the capacity and design of the various cards that are currently on the market to find one that will suit you.

8. Camera Size and Shape—Just as in selecting a film camera, you should consider the way the digital camera fits in your hand. Is it lightweight and comfortable, or difficult to handle?

9. Compatibility—Be sure that your camera and computer system can communicate effectively.

10. Cost—You should only make the switch to digital when it makes business sense to do so. Can you afford the camera you've selected at this time?

Rent Before You Buy. A digital camera is a serious investment. I suggest that you select two potential purchases, then rent both cameras for a day or two. Photograph the same subjects you work with everyday with each camera. If you photograph people (which, as the

Using two different makes/models to shoot a typical session is a great way to determine which one better suits you. Be sure to use each camera to shoot the same subjects, in the same situations that you encounter on a day-to-day basis.

title of this book suggests, I'm sure you do!), don't take the camera out to photograph landscapes or travel pictures. Work in the same situations that you encounter on a day-to-day basis. In other words, if you work outdoors, don't do your tests in the studio.

○ *Digital Media*

Digital media are what a digital camera stores each image on. While there are several types of cards/memory sticks used in consumer grade cameras, most professional cameras use a CompactFlash™ card. These cards come in two varieties. The first is the solid-state card (which is more expensive) made by Lexar, Scandisk, etc.; the second is the IBM® Microdrive® card.

All of these cards fit into an adapter that easily fits into the PC card slot of any laptop computer or a special drive that attaches to your desktop computer. The main differences between the solid-state card and the Microdrive card are in durability and cost. The IBM Microdrive comes in 340MB and 1G sizes. For the amount of storage space they provide, they are much less expensive than solid-state cards. Because of this large capacity, they are great for moving large files from the laptop that you used at home to your main computers at the studio.

While solid-state cards cost more, they tend to be more durable. I have heard photographers talking about Microdrives being dropped and not only losing images, but also completely ruining the unit. I have had other photographers tell me they forgot a solid-state card in their pocket, ran it through the washer/dryer and found that it still worked. (I tend to be more careful with my cards!) I have both and, luckily, have not had problems with either type.

As with cameras, most photographers buy the largest cards they can afford. While it's nice to have a 1G Microdrive to move large files from a laptop, that size isn't practical for normal studio use. You need a card that's large enough to store the images from your largest session. Then you need to purchase enough cards in that size to handle a day's worth of work. This can add up, so don't buy a larger-size card than you truly need.

● Lenses

Buy and use the best quality lenses that you can afford. In most cases, when you use a digital back on a camera that was designed to shoot film, the lens coverage is not what you'd expect when shooting film. This is because the camera chip often isn't the same size as the surface area of the negative the camera was designed for. This means that a 150mm lens could turn into a 175, 185 or 195mm depending on the difference in size.

If you look closely, you will find that the actual focal length of the lens is engraved upon it. However, the specifications sheet enclosed with your camera might list a different focal length or range of focal lengths. Therefore, while the engraved focal length might read 8mm–18mm on the lens, the specs might state that the lens is "*equivalent* to 38mm–86mm." To determine the equivalent focal length for your lens, read the specifications.

When photographing a client, many photographers use what would be considered a normal lens (50mm for 35mm camera/

The capacity of the CompactFlash card is its most important quality. Buy cards in the size necessary to hold your largest session rather than purchasing many lower-capacity ones.

Left: *A normal lens distorts the subject, usually making the face and body look wider and the nose too long.* **Right:** *A portrait lens (105–135mm for 35mm cameras, 150–180mm for medium format cameras) will give you a distortion-free view of your client and add depth to the image.*

75mm–85mm for medium format). A normal lens gives you a "normal" view—normal in that it's close to the perspective that the human eye takes in and normal in the sense that every hobbyist shoots with this lens because it's the one that comes with the camera. Clients will not pay for images made with normal lenses—they distort the face in close-ups and don't provide the necessary separation in full-lengths.

We use our 35mm-style digital camera with a 28–200mm zoom lens, which gives us a nice range of focal lengths. Ninety percent of our digital portraits are taken at a telephoto setting; it's considered a good choice for portraiture. With 35mm-style cameras, we use the equivalent of a 105–135mm. With medium format, we usually work at a focal length equivalent to 150mm (for 645).

A telephoto ("portrait") lens offers a distortion-free view that puts the subject in critical focus, yet throws the foreground and background out of focus. This adds impact to your images. Why? Because the out-of-focus foreground leads up to the critically-focused client, who is placed against a background that becomes increasingly out of focus as the background recedes. This accomplishes two important things: (1) it provides a sense of dimension in the image and (2) it focuses attention on the subject.

In film sessions, we always diffuse each image taken in the studio. The amount of diffusion depends on the composition. Head-and-shoulders poses are taken with heavier diffusion, full-length poses are taken with less diffusion. With digital, we don't have to diffuse a single image, because the appearance of natural diffusion is more noticeable. Another difference is apparent when you expand files to their limits: a head and shoulders pose might look fine, while a full-length image will start to become unacceptably soft. Without detail in the eyes, the image looks poorly focused; for this reason, we always do eye enhancements on larger portraits. We'll talk more about that later.

● *Autofocus*

Many younger photographers depend on an autofocus camera—it's what they "grew up" with. In the studio, when we hire new photographers, teaching them to focus a camera manually is sometimes a major ordeal. They don't understand why Bronica doesn't offer autofocus. Since many portrait photographers converting to digital will select a 35mm-style digital camera, though they are used to medium format film cameras, the same thing happens—in reverse. Many portrait photographers haven't worked much with a 35mm camera since

With digital, we don't have to diffuse a single image, because the appearance of natural diffusion is more noticeable.

This Page: *While we commonly add diffusion to all studio portraits shot on film, we don't have to diffuse a single digitally-captured image, because the appearance of natural diffusion is more noticeable.* **Opposite:** *While autofocus does the trick for most applications, remember that there will be times when you need to focus manually to ensure critical focus in the eyes.*

they opened their studios. Some still use their old manual focus Nikons or Canons (for snapshots at home), because they don't need them in their studios. Whatever the case, autofocus is tricky for the occasional user, especially when using it for portrait work where the eyes must be in critical focus.

I have heard more than one seasoned photographer tell me, "Watch the autofocus, it doesn't work!" It *does* work, you just have to know when and how to use it. While you do have the option to manually focus all autofocus lenses, autofocus can save a huge amount of time. The first thing you must do is read your manual and find out what type of focusing system your camera has and where the focus area is in your viewfinder.

In most autofocus cameras, a small box in the middle of the viewfinder represents the focus area. Some cameras have multiple boxes and multiple focusing modes. Standard focusing, using the center box, is fine, but you have to use common sense. In other words, don't expect the camera to focus on the eyes of your subject if that little box is placed squarely over a large stomach, bustline, etc., that's six inches closer to the camera than the eyes of the subject.

In a full-length composition, you place the box over the face, push the shutter release halfway down and it'll focus on the face. Leave the button depressed (which holds that point of focus), compose the portrait, then take the image. In a head-and-shoulders pose, you do the same thing, but you're close enough to put the focus box over the eye itself. I know this is basic stuff, but many photographers who aren't used to autofocus have problems with it. Autofocus is never 100 percent accurate, so you must always double check to make sure the point of focus is critically sharp. Remember that there will be times when you'll need to use manual focus to achieve critical focus in the eyes.

While you can manually focus all autofocus lenses, autofocus can save a huge amount of time.

● Lighting

Yet another factor that most portrait photographers don't consider is something called "white balance." White balance, for digital, is like color temperature for film. For instance, slide film is manufactured to work with light of a certain color temperature (most are balanced for daylight). Since portrait photographers don't typically work in direct sunlight, but in shade (which has a different color temperature), photographers using slide film use filters to correct unnatural skin tone/color. In digital, however, a white balance "reading" is used to compensate for each change in color temperature of the light. Most

cameras have an automatic white-balance feature, and in the cameras I have used, it works fairly well.

In the studio, capturing positive images—whether digitally or with film—also presents a problem for portrait photographers who are used to shooting negative film. Using negative film, as most portrait photographers do, you never have to worry about the color temperature of the light that your studio flash units are producing. They are designed to produce light that's close to the color temperature of daylight, which is what most films are balanced for. Variations between the brands of flash and the age of the flash tubes in those lights can change the color temperature. With negative film these variations are simply compensated for by the lab. Using slide film or shooting digitally, however, a color cast will be visible.

When we first started shooting digitally, the digital rep from our lab said, "Consistent color is more important than good color." What this means is that in most portrait studios, photographers have never had to worry about producing consistent color in positive captures like commercial photographers do. If you're like most photographers, you have a variety of lights from different manufacturers, and each one produces a slightly different color temperature. Another consideration is that the cheaper the light, the less consistent the color temperature. With negative film, you can use a $100 flash and it's fine, but with digital, that $100 flash will produce an inconsistent color temperature that will drive you crazy.

Portrait photographers usually don't replace flash tubes until they get black and crusted-over, which changes the color temperature of the light that's produced. When replacing flash tubes in professional brand units, spend the extra money and get the UV-coated type.

In our studio, 95 percent of our studio flash units are the same brand, which is great for digital. When we use lighting from a different manufacturer, the difference in the color produced becomes obvious when the automatic white balance is used. You have to remember, for a long time your lab has made it possible for you to get really lazy about shooting, but with digital, that's all over. If you have multiple shooting areas, with different brands of lighting, you'll need to spend a great deal of time trying to match the skin tone produced in one camera area to an image made in another. In portrait packages, where multiple poses are ordered from a single session, the skin tones in all of the images must match. Your lab has been doing it for years, now with digital, it's up to you!

To match the skin tones from one shooting area to the next, use lights from a single manufacturer. Remember that when shooting digitally, your images aren't as forgiving as they are with negative film images.

● *Connections: The Digital Umbilical Cord*

Most photographers have spent years trying to get all the cords out of the camera room. Well, guess what? In most cameras each image has to be downloaded through the camera software. The fastest way to achieve this is for the camera to be tethered to the computer so that your images are downloaded through the camera software and saved automatically. Typically, the software that comes with any given camera allows what is called "remote capture," which simply means shooting while tethered to a computer. Most photographers find this to be the most efficient and safest way to shoot digital—despite those extra cords! Fortunately, with remote capture, the image is stored in two places—and believe me, with digital, you need as many safety nets as possible. Unfortunately, with many cameras, this means you have to work fairly close to the computer.

Time is money, so download time is an important consideration. There are two types of interfaces that professional quality cameras use at this time, FireWire® and USB. FireWire currently has the fastest download time available. Like most photographers, I have a tendency to snap off pictures in a session at the speed of light, which is fine as long as I don't go over four or five frames. When you want to shoot larger numbers of frames in quick succession, the download time becomes especially important.

USB ports are standard on all computers nowadays. FireWire ports usually come with Macs and certain Sony computers. A FireWire port can be added to any computer for about $100. We'll talk more about computer needs later.

● *Accessories and Adapters*

Whether you select a digital back or 35mm-style camera, you'll need to change some of the tools you're used to using. Obviously, if you shoot medium format now and buy a digital back, the transition will be easier, yet more costly. Going from medium format to 35mm is going to take some getting used to.

Whether you have one shooting area or many, networking your computers to the viewing stations and dark-room computers can save time and lower the risk of losing images.

Filters. Throw away any and all filters you currently use that are called "warming." While warming works with negative film, it creates an unwanted color cast on positive imaging. All filters you decide to use with digital should be clear glass—you don't need color correction filters, because you have white balance!

Tripods. Photographers working with digital sometimes feel more comfortable using a tripod/stand with 35mm-style cameras. With a medium format camera and digital back, using a tripod/stand is a must. Inside the studio, I recommend a camera stand or a very heavy tripod with casters (large wheels). Most photographers go a little too far when they estimate the size of tripod they'll need to hold a camera securely to avoid movement. Camera movement is the least of my worries in the studio. I have flash units that will freeze any and all movement. I use a secure tripod on rollers so when one of my set movers bumps into the tripod, it will roll away rather than fall over, smashing the camera. I lost two cameras in one summer from this very thing. That's a hefty price to pay, when a set of heavy-duty casters for my tripod would have saved me thousands of dollars—my cameras were not repairable.

On our medium format camera we use a Lindahl bellows shade to hold the drop-in diffusion filter and vignetters. If you use a 35mm autofocus lens, you'll have to use screw-in filters and handhold the vignetters.

Normal attachments that photographers use on medium-format systems just don't work or don't work as well on 35mm autofocus. Most photographers use a bellows style lens shade on their medium format cameras, which serves many functions. It shades the front element of the lens, preventing light from hitting it and causing flare; it also holds drop-in filters (which can be pulled out quickly to check focus) and, finally, it allows us to use vignetters. (Vignetters soften the lines that lead out of the frame by turning the very edges of the portrait either darker or lighter. For low key [darker images] black is used, for high-key [lighter images], white or clear/crackle material is used.)

The bad news is that because of auto-focus lenses, this type of lens shade doesn't work on most 35mm lenses. On most auto-focus lenses, the front element of the lens rotates to focus the camera. This means that your lens shade will rotate as well. There is the Lindahl EFX lens shade that's made for auto-focus lenses. It has a roller system that allows the lens to focus without turning the lens shade. We have several of these but have found it difficult to keep the shade aligned, and even when they were working properly, the motor that focuses the lens seemed to strain to move the lens element.

If you use a 35mm type camera, you'll need to use screw-in filters. The vignetters you choose should either be the handheld type, which

takes a great deal of practice to get into the correct position consistently, or digitally applied (you'll have to add a vignette in Photoshop, which again adds to the amount of time you'll spend handling the particular image).

In closing, let me say that the brand of equipment you select is much less important than the way your equipment performs. You may be a Nikon guy with an arsenal of lenses, but if the brand that works best comes from another camera company, go with it. In digital, the wrong choice of camera means you must spend more time on each file in one way or another.

Cost is another important consideration. You shouldn't spend one dollar more on new technology than you need to, because we all know how fast new technology becomes old technology. It's also important not to be penny wise and pound foolish. Once you decide on the best camera to work with, stick with it, even if your second choice would save a few hundred dollars. That few hundred dollars will mean nothing when it comes to the time involved in making changes to each image you capture. And finally, remember, successful business people buy tools, hobbyists and the fool-hearty buy toys. If you can get by with two cameras/lenses/backs, then don't buy three for good measure. If the largest portrait size you sell is 16x20 inches, don't spend the additional money on a camera/back that will produce a 40x60-inch image.

The brand of equipment you select is much less important than the way your equipment performs.

THE COMPUTER AND DIGITAL PHOTOGRAPHY

Many photographers consider switching to digital without realizing how much is involved in the digital process. Once you purchase a digital camera or digital back, you must upgrade your computer(s) to be able to handle the workload and file sizes they'll now have to handle (or buy a new computer!). I don't care whether you decide to use a Mac or a PC, the process is the same (although you'll have more options with a PC and move more rapidly with a Mac). I'm not a "Mac guy" or a "PC guy," I'm a use-what-you-have-as-much-as-possible guy because, as you will see, digital gets expensive enough with just the basics covered.

You should ideally have two computers when photographing digitally. The first computer will be used to download your images onto. A second computer will be used specifically as a virtual darkroom. You'll retouch, color correct and package your images for the lab on this second workstation.

While you could get by with one computer, your workflow will suffer. Remember, your profits will increase as your efficiency in producing images does and, with that money, you will easily be able to pay for that second computer.

Time is a photographer's most precious commodity. In selecting and buying equipment, consider that spending money on the necessary equipment—and the education to use it—will bring down your costs. It's cheaper to get your studio up to speed than it is to pay staff to waste time struggling with confusing directions in an under-equipped studio.

● *Computer Basics*

Computers are expensive and become outdated quickly. Those sold to the average consumer are full of all kinds of junk you don't want or need, which slows you down and costs extra money as it eats up your time. When it comes to digital photography, the most important computer term is "RAM." No matter how much you have, it isn't enough. No matter how much you add, you'll want more. You now know much more than I did when I started out!

Most consumer computers come with 64MB of RAM; some of the larger computers have 128MB of RAM. The manufacturers of Photoshop® (which we'll be discussing shortly) suggest that you have twelve times the amount of RAM as the average file size you work with and, truthfully, that isn't enough. That means that if you work with a 20MB file, you should have at least 256MB of RAM (I can multiply—RAM doesn't come in 240MB)! I think that 512MB of RAM is a good starting place. Photoshop uses up RAM like there's no tomorrow, so buy as much as you can afford.

Remember, you should ideally have two computers, as each will be used for a separate, specific task. One is your capture/download computer; the other is your darkroom computer. While you'll need a lot of power, storage capacity and speed in your darkroom computer, your capture computer doesn't need to be a "beefed-up" version.

Computers will only work at the highest speed of their weakest link. With your darkroom computer, just about all work is done internally, so the speed of the computer and the RAM play a big part in how early you'll go home. The weakest link in your capture/download computer is your connection (your digital umbilical cord, which tethers the camera to the computer). Both FireWire and USB, the two available connections, have a set maximum download speed. You won't see a dramatic improvement in speed by using a super computer.

I don't like consumer computers, and there's a good reason why: I don't like to waste money. In my opinion, you're better off getting a computer that suits your needs—not one that contains a bunch of features you won't use, not to mention games that will tempt even your most honest, hardest-working staff members!

In every town, there are computer companies that will upgrade an existing computer. Upgrading is much cheaper than buying a new computer with the same amount of "horsepower" (slang for RAM, not a technical computer term!). There are two types of these companies—(1) the reputable computer company that uses quality parts and (2) the nonreputable computer company that would use bandages and duct tape if they thought they could get the computer to work until you walk out the door.

It is cheaper to get your studio up to speed by purchasing the best equipment you can afford and training them to use it than to pay them for downtime while they struggle with substandard equipment.

The local company I use has built/rebuilt almost every computer I use. With each purchase/upgrade I've made, I've saved $500–$600. These computers are designed to my specifications—they only have in them what I want them to have. Again, useless features just slow you down. (How many of you have bought the "latest, great-

Pull up some larger picture files the computer has in its database and see how long the computer takes to go to different drives and directories. You'll see that when you compare two computers with the same basic power, there will usually be a difference in how fast they work.

est" consumer computer, only to get it home to find it was slower than the computer it was replacing?) If you buy a consumer computer with a huge hard drive, fast processor, plenty of RAM and all the Internet software, games, pictures, encyclopedias (and everything else you can imagine), your computer will move at a snail's pace. And forget about removing that stuff. If it's in prepackaged software, you'll only be able to remove a small portion of it without affecting other software systems. We use the basic Windows® programs, purchased from the company that rebuilds our computers—and Photoshop—that's all we need.

One more point about upgrading computers: make sure you talk with people who have had computers upgraded by a company (and are happy) before you turn your old computer and money over to anyone. Buyer beware! If you feel more comfortable buying a consumer-type computer, go into a computer store and try out the various brands that are available. Pull up the larger picture files in the computer's database and see how long the computer takes to go to different drives and directories. You'll see that when you compare two computers with the same basic power, there will usually be a difference in how fast they work (depending on how much junk they have tried to stuff into that particular computer).

● *Storage Options*

When buying, building or rebuilding a computer, you not only need speed, which is determined by the processor speed and the amount of RAM, you also need storage. You need internal storage, which is hard drive space. Most photographers will install two hard drives in the 40–80G range. You also need external storage. Once a session is over, you need to get those files out of your computer and onto a removable storage medium (Zip disk, CD, external drives).

While some photographers use external drives (from Syquest® drives to Zips), the safest, cheapest form of storage are CDs. In order to store your work on CD, you'll need an accessory called a CD burner—and not just *any* burner, but the fastest one you can afford. CDs are your new negatives. You'll burn dozens of CDs. Because time is money, the faster the CD burner, the more money you'll save.

We use writable, not rewritable CDs. A standard, writable CD is a permanent, unchangeable storage medium. You can't accidentally hit Save and lose your original file. Since you can't reburn or change a writable CD, you don't have to worry about carrying a virus from a computer that's hooked up to the Internet to your darkroom com-

puters. And best of all, they're cheap. You can get them for $.30 apiece if you buy them in bulk or in the large packs at club stores like Costco/Priceclub, etc.

When setting up your computer you want your CD writer/reader and hard drives to be internal (built into your computer) rather than external (connecting with a cord). External CD writers and hard drives seem like a good idea because you can move them easily from one computer to another. While this saves you money (because one piece of equipment can be used by many computers), it costs you in time. Again, the computer will only work as fast as its slowest part, the connection cable to the CD burner/hard drive. Most computers have space for two internal CD readers/writers. For the duplication of CDs (which you have to do with each session) it saves you a huge amount of time to have an internal CD writer/burner, as well as a standard CD reader.

● *Transferring and Transporting Images*
We've spent some time talking about handling the information in the computer and storing processed images on external storage devices, but how do you get the information into the computer in the first place?

There are two quick ways to get the information from your camera to your computer and from one computer to another. First, you can have your computers networked together. This is the best way to get information from one workstation to another. This works well if you have a really small studio and a small budget or a really big studio and a really big budget, but not if you're somewhere in the middle. Let me explain.

If you have a small studio, you typically have one shooting area. You can have a PC in your shooting area that's attached to your camera. This computer should be networked to the darkroom computers, making the transfer of information between the two fast and easy. When a studio has many shooting areas, the setup is the same. In our two studios we have twelve shooting areas. There is a PC in each one, and a network that runs over a large area. This setup is expensive, but it's one quick way to handle the exchange of information.

With the software provided with your digital camera, you'll be able to manage and sort your images into specific client files for a neat, organized retrieval/storage system. The software provided with each digital camera model/brand is different, however, and the difficulty you'll have in accomplishing this will depend on that software.

There are many ways to get the information from the camera to the computer and then from one computer to another.

Left: *When you need a mobile digital shooting station, an audio-visual cart and a laptop work wonders.* *Right:* *Using a card reader with a FireWire connection is a low-cost, high-speed way to transport files. A quality color inkjet printer is a must when a print is needed immediately. While these prints are not durable, they are fine for quick yearbook or publication prints.*

The second quick and easy way to get the files from the download computer/camera to the darkroom computer is to use the Compact-Flash card in the camera. When we first began using digital, we used a camera connected to a laptop. We put the laptop on an audio visual cart that we bought at Office Depot. We'd roll the cart from camera area to camera area, following a client from the beginning of their session to the end. This way it was easy to keep all the images in one client file. We'd then take the CompactFlash card to the computer in the salesroom or darkroom, depending on what we were doing with the captured images.

Each of our salesroom and darkroom workstations contain a CompactFlash card reader with a FireWire connection. This isn't a little USB card reader that you get for free when you buy a CompactFlash card. This particular card reader costs around $100 and, for speed, requires a FireWire connection. Of course, in order to use a FireWire connection, you must have a FireWire port installed in your computer, which also costs around $100. This setup enables us to transfer the captured images to other computers without major networking and expense.

I hate to say this, but most people who buy computers tend to select them based on looks. They always get sucked in by a comput-

I hate to say this, but most people who buy computers tend to select them based on looks.

er with a unique look. One of my computers had a keyboard with an entire row of buttons (which ran the length of the keyboard) that worked with special Internet software. The idea was to have a button on the keyboard for all of your frequently-visited web sites. This was the slowest computer I ever owned. It'd take at least ten to fifteen seconds to go from one drive to another while it waded through all its prepackaged software. I finally had it upgraded about three months after I purchased it.

As far as computers go, the requirements/options covered above are a start. I haven't talked about processor speeds because, quite frankly, they change so quickly. By the time you read this book, we'll probably have upgraded our computers with the newer, faster, bigger and better processors available.

⬤ *The Internet*
One last thing—never hook up any computer you'll be using for your studio images to the Internet—*never!*—especially if you have employees. Once you go online (and especially when you check your e-mail) you can download a virus. I used to think you had to open an attachment to an e-mail before a virus would attack your computer. As I was writing this book, I checked my e-mail on my laptop. All of a sudden, I was getting e-mail after e-mail about sending a virus out. Once in my computer, the virus used my contact list to automatically send out the virus to everyone I correspond with. I talked with my service provider and they explained that although most computers come with a virus scan that detects and stops viruses, they become outdated as hackers develop new viruses. So you have to upgrade your virus scan by visiting the web site of the company that produced it and downloading the current (free) version. Still, this doesn't guarantee safety since hackers come up with new viruses daily.

The virus in my computer was a mess. I finally had to reformat the hard drive and reinstall all the software I use. Luckily, the first thing I did was to save the first three chapters of this book on a couple of diskettes, but this would have been a real disaster in any of our studio computers. No phone lines should ever run into your studio computers. Otherwise, a bored employee's "computer break" might force you to rephotograph sessions and reinstall software for countless hours.

Maintenance is another often overlooked task that should be done regularly. In each Windows program there are a variety of functions that keep your computer running at top speed. As I said, we delete

Never hook up any computer you'll be using for your studio images to the Internet . . .

any programs that aren't used. We run a scan disk and defragment the hard drive at least once a week. This takes hours to complete, so we start these functions at the end of the day and they run through the night. There are a variety of aftermarket applications available that clean up your hard drives and makes them function more efficiently.

ADOBE PHOTOSHOP AND IMAGE EDITING

Information about Adobe Photoshop could easily fill an entire book (actually, several). My goal here isn't to teach you Photoshop, but to share some information on important tools in Photoshop that make your production work faster and easier. Lots of people are talking about digital and all the artsy things that it can do. However, when you shoot digital in your studio, 95 percent of what you're doing in Photoshop isn't artsy stuff, it's run-of-the-mill production work; it's getting the needed work done on each image, then packaging it to send to the lab.

I don't want to make light of the "artsy stuff," either. It's very easy to manipulate images, add effects, finishes, text or graphics to images. This type of portrait can be fun for you as a creative person and exciting for your client, as well. Keep in mind that you're in business to make a profit, and to stay in business you *must* earn that profit. If a special-effects portrait takes an hour to create, you'd better be able to bill your clients for that time.

There are many pieces of software on the market that are written to work with Photoshop.

Now here's a helpful hint: make sure that the services you offer your clients are actually desired by them. Now, this sounds like common sense, but it's a trap that's easy to fall into. For example, bridal photographers in Fresno sometimes display portraits taken at the beach. The only problem is, the beach is three hours away from their studio. Most client's can't afford to pay the photographer to travel three hours for a photo session. So by hanging the portrait, the potential client is lost. The same is true of playing around in Photoshop. If you want to spend hours working on a portrait for your own satisfaction, that's fine, but don't show anything in your studio that you can't realistically reproduce for the average customer.

There are many pieces of software on the market that are written to work with Photoshop. These "plug-ins" allow you to easily create additional special effects options within the Photoshop program. Some of the special effect portraits used in this chapter were created using plug-ins available through Morris Grover's PhotoArt (see the resources section for contact information). While special effects like these can be created in Photoshop without plug-ins, creating them will take a great deal of time and, again, time is money.

It's easy to get carried away in Photoshop. It has the power to create some of the most incredible images you've ever seen and the power to take up just about every extra moment in your life. Remember to balance your *desire* to use it with your actual *need* to use it. Creativity is nice, but your kids need a parent, your spouse needs a husband/wife, and every other aspect of your business still requires your attention.

● Special Effects
Simple special effects were used to create a unique look in the portraits found in this chapter. They aren't as involved as many of the Photoshop images you'll see displayed at seminars, but these aren't just for show—these are practical to produce for the buying public. In the captions, you'll see how we created each image and the tools that were used.

● Using Layers with Templates
One option for artsy images is a template—a layout device for photographers that can be easily personalized for many clients. Most photographers working with digital use templates because they can be made quickly and are pretty cool to look at. Templates work well in the high school senior market.

Templates use layers, which is one of the most important tools in Photoshop. Everything you add to your original image is done on a layer. You can edit, change or duplicate any of the layers right up until you flatten the image, which is the final step. All labs work with images in a TIFF format, which does not typically allow layers to be saved. In Photoshop version 7 (and later), however, this became an option. You can now preserve layers in a TIFF format by activating Layers in the Save category of the Save As dialogue box. You can enable or disable a warning that inquires whether or not you want Photo-shop to "Ask before saving layered TIFF files" by going to Edit>Preferences>File Handling. However, most images saved with layers are saved as PSD files.

Opposite: While Photoshop can be used to retouch images, correct color casts and more, it is easy to get in over your head and create time-consuming images that may appeal to many but be affordable for few. When creating special effects, try to remember that time is money.

No special effect will ever save a weak image, nor will any one effect be right for every pose. As a rule, when using a special effect that distorts the image, the face should be larger in the image. This will produce a salable print.

Above and Opposite: *You can create special effects portraits easily by using the pre-set actions provided in Photoshop or you can purchase plug-ins (special applications designed to work with Photoshop) that will increase your options.*

When you buy templates, you'll see the image represented in layers in the Layers palette. There will be a layer that contains graphics and layers to paste images into. (If the Layers palette isn't visible, simply go to Window>Select>Show Layers; you'll also see the names of other palettes you might need to bring up, as well). To work on the portrait, you simply highlight the layer you want to work on. To place the image in the template, simply open the image, go to Select>All then to Edit>Copy. Then, close down the window containing the image, and activate the Paste Into layer in the Layers palette. Hold down the Control key and click on it a second time to bring up the selection indicator ("marching ants") around the area you'll paste your photograph into. Go to Edit, and select Paste Into (not Paste). You'll see the photograph behind the layer that frames it. The next step is to size and angle the photograph so that it properly fits into the framed area. Go to Edit>Select>Free Transform. You'll see a box appear around your photograph. To size the portrait, hold down the Shift key (to keep it in its original proportions and not distort it) then

bring the cursor to one corner or the other and click and drag to size as needed. If you need to change the angle of the portrait, bring the cursor to the top of the photo and you'll see a curved line on the cursor. This will allow you to rotate the image. Since you're not sizing when you rotate, you don't hold down the Shift key for this operation. You can drop all the images into the template in the same way.

The next step is editing or adding text. Photoshop has come a long way in making it easy to add and edit text. First, choose the "T" on your toolbar. Determine the area in which you want the text or, in the case of templates, click on the last letter in the text layer and erase it. Then type out the text you want to add. Once you have the text typed out, you can set the text with the Move tool. Once the text is set, highlight it. Next, go to the text option box. If you don't know what font you want (with your text still highlighted), you can scroll through the font menu, then highlight any font name and you'll get a preview of the affected text in the new font. This saves a huge amount of time if you have as many fonts as I do. That's it. In just a few minutes you've created a salable graphic image that will produce a nice profit like any other portrait!

Template layouts are available through protemplates.com, as well as through many other sources.

Templates are premade layout devices that combine images, graphics and text to create unique portraits. They are very easy to use, and can be created quickly.

Top: You can turn a great image into a must-have, one-of-a-kind montage with a template that incorporates eye-catching graphics and text. **Bottom Left:** Each template is set up with the layers preserved. You will see each of the graphic layers and the "Paste Into" layer listed in the Layers palette. To place the first photograph, copy the image to be placed into the template, then highlight the Paste Into area by holding down the control key and clicking on the words "paste into." Then, select Edit>Paste Into. To size the image to fit, go to Edit>Select>Free Transform. Hold down the shift key to retain the image proportions. **Bottom Right:** While you can create your own template designs, the first one is always time-consuming. Layers are used to build up the image and the order of the layers determines how the photographs will overlay each other. To fade an image, simply copy an image and reduce the opacity of the layers. To add a drop shadow and other effects, go to Layers>Layer Effects.

Layers are also used with non-template portraits. With seniors, almost every order calls for what labs have always called "lithos." A litho is the white lettering in the lower right-hand corner of wallets (usually the client's name and school year). When we first began tackling the production of our images, I'd put the text on each image individually, which took up a great deal of time. Now, using layers, I open each image that I want to apply the same litho to. Then, I add text to the first image, and edit it as described above. Using Free Transform, I rotate the text and place it in the corner. (If you want to get fancy you can go into the Layer menu and select "Layer Style." This will bring up all kinds of options from "drop shadow" to "outer glow"; these options can further enhance your text.) When the text looks the way I want it, I go back to the Layers palette and select Duplicate Layer. A box will appear and ask where you want to duplicate the layer to (you'll have the option to duplicate the layer in any of the images that are open). You can place the litho on one pose, then

To apply lithos quickly to multiple poses, just add text to one of the poses and then go to Layers>Duplicate Layers. A box will ask you where the layer should be duplicated. Next, duplicate the text layer to all the open poses to apply the litho to each of your wallet-sized prints.

Labeling Your Images

To learn more about layers and Photoshop in general, go to the Photoshop web site at www.adobe.com. They list seminar dates and locations for Photoshop classes. While the classes are certainly worth your while, Adobe also produces videotapes that deal with some of the primary tools like layers, actions, text, etc. Learning Photoshop keyboard shortcuts is also helpful. Using them makes completing various tasks easier and quicker. You'll save yourself a huge amount of time once you memorize them.

duplicate it to all of the other wallet poses. Next, you can send all of the individual photographs with the lithos on them to the packagizing software.

● *Actions*

From a production viewpoint, using actions is a real time-saver. Actions work like a tape recorder, recording any work you do to a file. Once you finish the work on an individual file, you push the play button and it repeats that work on multiple files with a click of the button.

To view the Actions palette, go to Windows and select Actions. To create a new action, click on the pull-down menu at the top-right corner of the palette. All of the changes you make to your file (image, text) from this point on is recorded as a new action, so make sure to plan ahead. Some changes (like paintbrush strokes) can't be recorded as actions, but most can.

If you've never used actions, let me give a "real world" application. Let's say you have an order to fill. You have a package of portraits that consists of six poses. In this order there are a variety of image sizes. You now need eight 4x5s to fill a folio (one of each of the client's six poses plus two additional images). Because you'll need to change all eight images to a TIFF file format, and crop all eight images to a 4x5-inch size, you can save yourself a lot of time by allowing the actions function to complete the work for you. Here's how:

Actions work like a tape recorder, recording any work you do to a file.

1. Open up all eight images. Most cameras capture images in a JPEG format, but editing JPEG-format images degrades the image quality. Each file must be converted to a TIFF format.

2. In order to create a new action to change images to a TIFF format, you'll first need to click and hold the right-facing arrow in the top right-hand corner of the Actions palette, then select New Action. A New Action dialogue box will pop up. You can then name your action (if you do not type a name, your action will be automatically referred to as Action 2). Next, click on the button labeled Record in the Actions dialogue box. Now you'll begin to record the changes that will be made to your image. You'll want to be extra careful—any mistakes you make will be recorded as well. If you make an error and click the Stop button, you can resume recording by clicking on the the record button (●), which is found at the bottom of the Actions palette.

3. Go to File>Save As. Under format in the Save As dialogue box, select TIFF, then click Save. A second dialogue box will give you the option to compress the image, and select a Byte order (PC or

Top: If your Actions palette is not visible, go to Window>Show Actions. From there, click on the actions tab. *Bottom:* Recording a new action is simple. To begin, click on the actions tab in the palette found on the left-hand side of your screen.

Mac). When you've made your selections (or left the default settings active), click OK.

4. You're now ready to record the step that will save all of the files, once altered, to your specific client's file folder. Once again, go to File>Save As. Click the New File button on the right, and label your new file with your client's name (or in some other way that makes file storage and retrieval work for you). Click Create, then name your image, clicking on Save when you've finished.

5. Next, we'll record the step that will crop each of the eight images. At this point, we're still recording, so select the Crop tool, and enter the desired height and width in the menu at the top of the screen as "5in. by 4in." (most cameras capture both vertically- and horizon-

There are many preset actions available in Photoshop. Go to Window>Show Actions, then open the default actions folder—you'll find all of the preset actions listed there.

tally-oriented images in horizontal position—that's why we've reversed the numbers!). Next, enter 300 (or whatever your lab recommends) in the resolution field.

6. With the settings selected, use the Crop tool to make a crop selection to the image that will work on all eight images (if your images need to be cropped quite differently, it'd be best to record a separate set of actions for some of the images!). You'll notice that the Crop tool will select a 5x4-inch area. With this complete, you'll notice that the areas of the print that will be cropped out are grayed out. Double-click in the center of the image to crop it, then, using the steps outlined above, create a new folder (named "4x5s" or something similar), and save the cropped image to this folder. With the cropped image on your screen, go to Edit>Step Backward to retrieve the full-sized image—once you've made all of your 4x5s you'll want these full-sized images to create the sizes needed for the other prints in the package.

7. With all of the necessary steps recorded, it's now time to click the Stop button (■) in the Actions palette. Switch to the next of your eight images. In the Actions window, use your cursor to highlight the name of the action you recorded. Click the play button (▶), and within a few seconds, the action will convert the new file to a TIFF file, save it in the client's folder, then crop it and save it in the 4x5 folder and, finally, will step backwards, leaving you with the image to crop for the portrait package.

As you can see, recording these actions takes only minutes and reduces the rest of your work on multiple images to a click of the mouse.

As mentioned earlier, with the files converted to TIFF, the images are ready for any necessary retouching.

Preset Actions. With preset actions, you can apply a vignette or sepia tone to an image—among other things. These actions are found in the folder named Default Actions found in the Actions palette. To check out the many options available, just click on the folder and experiment on a trial image.

● *Batch Processing*

Batch processing is used to apply a series of actions to an entire folder of images. If you have to convert a whole folder of JPEGs to TIFFs, you can do this quickly and easily. To use the batch process feature, go to File>Automate>Batch. In the Batch window, select "Convert to Tiff" under Action. Next, fill out the necessary fields in regards to which folder to get the original files from and where you want to put those files once the action is complete. Once all the information has been entered, click OK, and the changes will be made to all of the files in the specified folder.

What many photographers do is batch process all the images in a client file to convert all of them to a TIFF format, then open the specific images the client has ordered so that the images can be individually retouched. Actions can then be used to enact any repeatable tasks. Simply put, if you experiment with these features, you'll find many instances in which they'll make your job a lot easier.

Batch processing is used to apply a series of actions to an entire folder of images.

● *Retouching*

While using Photoshop can help you to complete your work quickly and easily, using it is only profitable if you make improvements that are absolutely necessary. Trying to retouch everything in the portrait is a big waste of time *and* profit potential. I've heard photographers make ridiculously bold statements like "It's digital, we can fix anything!" When I hear this, I know that photographer will have no free time whatsoever, or will lose his or her shorts paying for all the hours the studio's employees will spend making minimal and often unnecessary corrections.

When working in Photoshop, you have to allow a certain amount of time for retouching a file, and that's it. If a portrait requires more time than that, your retouching is artwork and, at that point, you

need to give your client an estimate just like you would if you ordered those services from a lab.

A photographer once told a client that he would retouch out a girl's braces for no additional charge. I happen to know that this guy's not charging enough for his finished portraits to make a dent in the amount of time/money this would take. In our studio, each client pays a pose change fee, whether the session is digital or film. That fee is modest and covers the cost of retouching and testing the first image ordered from a file/negative. I have tracked how long it takes me to clean up a file as well as the lab's negative retoucher does (actually, my retouching job is better, because digital is more thorough). I averaged out the time it takes to retouch most images: it takes less than a minute and a half to adequately clean up the average person's face. This became our standard amount of retouching time. In our studio, if we expect that the retouching will take any longer than that, we give the client an estimate for the work.

When retouching images, you'll not only have questions about *what* you should retouch—but also about whether or not you should foot the bill for that work. There are times when, to keep a client happy, you should eat the cost of a little extra retouching work. For example, if there's a problem with eyeglass glare in an image, did you inform your client that he needed a pair of empty frames for the portrait session? If you did, the client should be 100 percent responsible for the cost of retouching. If you didn't, you'll probably need to absorb that cost, and change the way you handle your clients. If a client spots a problem with a background (tears or marks), scuffs on a white floor (or anything else that we photographers get lazy with and don't repair/paint/fix when needed), etc., the cost will need to come out of your pocket.

Again, if you're not careful, you'll spend more time and money retouching—removing stray hairs, taking wrinkles out of clothing, swapping heads and all the other ridiculous things that many photographers do—than you can afford. This is grunt work. As a photographer, you can earn $100, $200, or even $500 an hour when you're behind the camera. When you're at the computer, you're a minimum wage employee. Every task that pulls you out of the camera room had better pay you a lot more than minimum wage!

The Clone Tool. In Photoshop, wasting time seems to be what photographers do best. They overuse just about everything, use tools improperly or simply attempt to use the wrong tools for the job. The Clone tool is every photographer's favorite instrument.

If you're not careful, you'll spend more time and money retouching than you can afford.

*This Page: To control costs, you have to standardize the amount of retouching that is done. We retouch acne, soften the dark under-eye area, and enhance the catchlights in the eyes. Anything more than this is considered artwork, and we bill the client for the added labor. **Opposite:** This minimal retouching results in a much-improved image.*

The Clone tool is the tool of choice for retouching. It's a great tool when used correctly, but most photographers start off working with the opacity set too high. When you retouch a portion of an image, you want it to blend in seamlessly with the rest of the portrait. To accomplish this, you should use a soft edge brush and a low opacity setting (around 25 percent). If you're producing a wallet-size image for a client, do the on-screen retouching on an image that's about 4x5 or 5x7 inches on the screen. If you're creating an 8x10, retouch an image that's 11x14 inches in size. Retouching at this size will help you to keep your retouching needs in perspective—if you can't see a blemish on the screen at this enlargement, your client

If you retouch only what is necessary for the final print size, you'll save huge amounts of time each month.

won't be able to see it in the wallet-sized print, either. If you consistently retouch only what is necessary for the final print size, you'll save huge amounts of time each month.

To enhance your speed with the Clone tool, select a brush that's slightly larger than the largest blemish you need to retouch. With the entire face showing on the screen, start at the top of the forehead. Press the Alt/Opt button then left-click on a similarly-toned area close to the blemish (usually just above or below, but sometimes at an angle) to sample the unblemished area. Then move the cursor to the area that needs retouching. Once you have removed or softened the blemish to your liking, visually scan the face for any other blemishes that can be retouched with the same brush setting. Reset your

brush to a size that's well-suited to smaller blemishes next, and work through any remaining problems. In doing your retouching this way, you won't waste time setting and resetting the brush size over and over again.

The best way to retouch a file within Photoshop is to develop a routine. This is a consistent and efficient way of working with a file, taking it from conversion to being print-ready. Once you develop a routine, you'll be able to control your costs by teaching this routine to your employees. No matter how small your business, you'll need someone other than yourself to work on each file and get them ready for the lab, because you can't sustain a photography business doing work that's worth $8–$10 an hour.

● *Managing Your Workflow*
The lab that processes your film uses a specific system when handling your work. They first ensure that nothing will happen to your original film images, then take certain steps to produce proofs. After the order is sent in they retouch the negative, print your order and use artwork to clean up any of your mistakes. They've developed this method through years of trial and error—and, I'm sure, a great number of mistakes along the way.

Because digital is relatively new, we're still figuring out how to best manage our workflow. Digital requires a new way of doing things— sometimes we incorporate methods that work in other studios, sometimes it's trial and error.

As a businessperson, I'm not as impressed by what can be done in Photoshop as I am by how little time it takes to complete the work. Again, there are only a set number of things that you should spend your time on with the average portrait. That's why I've focused on simple ways to complete the tasks you'll encounter every day.

As I said earlier, the photographer is responsible for a lot more than capturing an image. He or she has to ensure that there's a solid business system in place to take that image from capture through the time the final order is picked up by the client. With film, the majority of that business system was performed by your lab—but no more: *you* are the system now! Fortunately, Photoshop plays a large part in this system.

● *Protecting Your Images*
After digital images are captured, your first concern (just like your lab's) is to safeguard your original files. Immediately after a session,

There are only a set number of things that you should spend your time on with the average portrait.

The images from each shot should be burned onto two separate CDs and stored in two places: one in the studio and one in another location so that in the event of fire or another disaster, all will not be lost.

You can reduce the time you spend on retouching by providing a comprehensive consultation for each client. When you address things like proper clothing choices, hair, makeup and eyeglasses—and just what corrections will be carried out free of charge and which the client will need to pay for, your session will go more smoothly.

burn two CDs containing all of your original image files. Put one into the client's file, and one in a darkroom file. In our studio, the files are stored in two separate buildings. Some photographers have only one studio building, but store a second CD in another location in case of fire. Two CDs are always better than one—with two, you've always got a backup if you accidentally misfile, and for all intents and purposes *lose* the first CD. (By the way—what have you done with your negatives? Are they stored in a fire-safe vault, or do they sit in your filing cabinets, under your fire sprinklers, which would ruin them if there was a fire?)

The more hard drive space that's used, the slower the computer runs.

At the end of each day the folders containing the images in the computer are deleted to clear space for the next day's sessions. The more hard drive space that's used, the slower the computer runs. Again, this is why we burn CD copies of our work after the session is over, then delete the original file. Make burning the CDs then deleting the original files from your computer a ritual. If you put it off once, that will be the time you forget, delete the files and feel like an idiot when you have to call a client back to reshoot their session.

Always double-check that you're copying the right files, too. I'll never forget the first session I lost. A young lady was going out to do some beach photos for a new mailer I was working on. I didn't want to take my laptop to the beach as a backup, and since it wasn't a paying session, I just recorded the images on the CompactFlash card. I viewed the original images at the studio. I needed the flash card for all my upcoming sessions, so I burned and labeled two CDs and deleted the girl's images from the card. Three days later, I popped in the CD and found images of a young man. I checked the second CD and it was also the young man. I either downloaded the images from the wrong flash card or selected the wrong file to copy. Needless to say, it's a good idea to use different brands of flash cards or label them clearly. I felt like an idiot when I had to call her!

Once the images are secure (on CD) you can produce whatever form of proofing you'll be using (we'll discuss that in chapter 8). You'll then hopefully have an order to fill. Some orders can take five minutes to complete, while others will take forty-five minutes. The amount of time it takes, of course, depends on how many poses are ordered and how many add-on items (like templates, folios, calendars, etc.) are ordered. We've already discussed the first step in production, which is opening the original files from each pose that's ordered (either in the package order or add-on items). In our situation, we set up an action to convert JPEG images to a TIFF images (as discussed on page 53–55). Because we only retouch the images that the client selects, only some of the images in the client's digital folder require retouching. While eight images are needed to fill a folio, since the client has only ordered two different poses, he or she is only charged for the retouching of two 4x5-inch images.

After using actions to convert the file type, we then retouch the file, if a pose change (retouching) fee has been paid. We retouch any blemishes that will be visible in the manner explained above, and also soften smile lines and retouch dark circles under the eyes. The studio doesn't fix hairstyles when the client has a bad hair day. We don't

If you color correct your own files, the amount of color correction that you'll need to do will depend on three things: your camera, your consistency in shooting your images and your printer's ICC (International Color Consortium) profile.

remove wrinkles from clothing, alter white socks showing beneath dark pant legs or erase braces or glass glare unless the client is paying for the time to do this. (For a realistic fee to charge per hour, ask your lab what they charge and charge the same price at the same increments.) We are justified in charging to correct these problems since we inform our clients repeatedly about the problems that can arise in a session due to poor planning. We provide our clients with an 11x17-inch color brochure and a take-home consultation video that outlines those things that can make a great session turn bad. Because some people don't get the message the first time, there's another video playing on each monitor in every waiting room in our studio. If someone comes in with lenses in their glasses, you'd better believe that they know in advance that we'll charge them to fix the glare.

● *White Balance and Color Correction*

After the basic retouching is complete, the color correction is made to all the images, including the files for the folio (unless your lab does this for you). With a quality camera, if the white balance is set correctly, you'll only need to make simple changes in lightness/darkness *if* your lab makes the final color correction for you. To adjust density (lightness/darkness), you'll use the Levels function.

To begin, go to Image>Adjust>Levels. You'll see a histogram, a little picture full of jagged lines that represent the full range of tones—from light to dark—in your image. To adjust the contrast in the image, pull the sliders (labeled "shadow" and "highlight") positioned on either end of the histogram inward until both arrows are directly under the outermost bit of data on either side. Once the contrast is set, you can use the center (midtone) slider to further lighten and darken the image. In most cases, this effectively changes the density and contrast without affecting the color balance.

If you color correct your own files, the amount of color correction that you'll need to do will depend on three things: your camera, your consistency in shooting your images and your printer's ICC (International Color Consortium) profile. An ICC profile is basically a filter that goes over each image that shows you the way that the printer will render the colors. Work with your lab closely while you're building your color balancing skills. Most photographers aren't accustomed to working with critical color. They don't realize that everything from the color of the room you're working in, to the lighting in that room to the color of clothing you're wearing can affect the color on the monitor.

Work with your lab closely while you're building your color balancing skills.

● Filling Orders

From this point on, you'll need to resize the images needed to fill your client's order. To begin working on an image, first save it in a new client folder, which will hold all of the images that will be sent to the lab. If a proof set is needed, set up the cropping action, and save the cropped images for the proof sheet in a separate subfolder (a folder within that particular client's folder) and then step backwards so you can work on the image in its original size.

There are two ways to fill the order. Our lab wants the size of the print to appear in the file name, so we crop and save to provide this. If your lab asks for this, you can "packagize" (set up unit packages) from one retouched file and then rename the individual files. Since we work only with seniors, lithos are added to almost every order. Since the cropping of wallets is narrower than an 8x10, we crop our wallets to 5x7 inches (you could also crop to a wallet size). This way, we know exactly where the litho will appear in the final portrait. So, if we need an 8x10 and sixteen wallets from a single file, we crop and save two files, one 8x10 and one 5x7. We repeat this process for each file needed to fill the client's order.

What you end up with is a number of files in the subfolder you've named "for Johnson folio" (or whatever) and then the folder filled with the original images, as well as the cropped images. Next, create a subfolder named "UnitPrintingforLab." You can drag and drop the 8x10-inch images into this folder, because if you've cropped the image to 8x10 inches and that's what you are ordering, you don't have to package it.

If you want two, make a copy in the unit-printing file. Now open all the 4x5-inch images in your folio subfolder. Once all of them are open, go to File>New, name your file and enter the dimensions 8x10 or 10x8, depending on whether all your images are vertical or horizontal. Under Contents, select White. Under Resolution, type 300dpi. Next, drag and drop each 4x5 onto the blank 8x10-inch page (you'll need to create two pages). Alignment is fast and easy. Once the first page is full, flatten the image and save it to your UnitPrintingforLab folder. Finish the second page and do the same thing. If your lab is doing the final color correction, save these pages as Photoshop (PSD) documents, without flattening them.

The final step is to use your packagizing software. Talk to the folks at your lab to see what they recommend. I use the same packagizing and color calibration software that my lab uses so that we're on the same page.

I use the same packagizing and color calibration software that my lab uses so that we're on the same page.

Photoshop has a packagizing capability, but my lab provided me with the Packagizer™ software by Plug-In Systems, and I'm happy with it. Basically, you open your retouched file. You can use a cropped-to-size file (a 5x7 file for a 5x7-inch print) or you can have one standard image size that will be formatted to fit each size in your packages. I use two sizes of originals: a 5x7 for 5x7-inch prints and wallets, and an 8x10 for 4x5-inch prints. You don't have to package 8x10s.

Select the original file. Next, select the number of units (defined as an 8x10-inch sheet, one unit is equal to one 8x10-inch image, two 5x7-inch images, etc.) and sizes you'll need from that file (it will print as many units from a single file as you want). Save the files to the UnitPrintingforLab subfolder, then select Print. The software creates the units and, as you requested, puts them in your client's folder.

When the images have been processed, burn a CD and send it to your lab. Our lab also wants a printout of all of the files contained on the disc—to be included with the CD—so they can do a final check without having to open the CD. Although they have a written invoice, it only lists the total number of units, and not what's ordered from each file. That's why they ask for inventory lists, which many labs provide for their photographers.

Again, this is using Photoshop as a tool, not a toy. If you want to create a masterpiece montage or snappy special effects portraits, that's great. But truthfully, most of the Photoshop work required for portrait photography is a little less exciting. This job isn't quite as glamorous or as much fun as most people envision, but it makes money if you get the job done fast! Photoshop helps those new to digital realize two things: beneath all the hype about digital is the opportunity to increase profit—and the "opportunity" to take on a lot more responsibility.

The software creates the units and, as you requested, puts them in the client's folder.

● Monitors and Calibration

The monitor you use and the way in which that monitor shows color is one of the most important pieces in the digital puzzle. You can't color correct an image unless you know that the color your monitor is showing is accurate. For example, think about the rows of televi-

sions at the appliance store. When all of the TVs are tuned into one station, you can easily see the difference in the way different sets render color and contrast. Some computer stores have their monitors set up in the same way, and while there isn't as much difference in monitors as in televisions, there is a noticeable difference in the way monitors display color.

Buy the best quality monitor you can afford. This 19-inch Sony Trinitron is a good basic monitor for work with critical color.

Whatever you do, don't buy a $99 monitor. For color-correction, you'll need the best quality monitor in the largest size you can afford. (Don't rush out and buy a new monitor for your download computer! The 14-inch economy brand that came with your computer is fine for this workstation!) While some photographers will spend literally thousands for the latest and greatest graphics monitor, it really isn't necessary. After talking with my lab, the first monitor I purchased was a $500, 19-inch Sony Trinitron®, and it has worked very well. Whatever you do, don't listen to the guy at the computer store. You're using this monitor for a specific purpose and unless that salesperson is a digital photography student, he or she isn't going to know anything about monitors beyond their basic specs. I just can't say enough about using your lab as a resource when selecting hardware and software.

When selecting a monitor, you must also decide whether or not you'd like to purchase two. Why? With two monitors, you double your working area. If you want to do work as quickly as possible with multiple images to create a single image (head swaps, complex montages, changing backgrounds, etc.) a second monitor is a good idea. Since I want to expand my wallet, not my imagination, through Photoshop, I create the art in the camera room and use a 21-inch monitor at each computer I use for Photoshop. But the choice is yours.

Another important consideration is the environment that you place your monitor in. You think you've escaped the darkroom years ago, right? Well, guess what: you're going back in. The room in which you work on your images needs to be dark. There should be no overhead light used, and only a small amount of window light (at most) coming in. You don't have to black out the windows like a darkroom, but you should most definitely close the shades.

In addition to keeping the space dark, you'll need to paint your walls black or at least gray so they don't affect the color you seen on the monitor. The clothing you wear also affects the color on the monitor. Blue may bring out the color of your eyes, but it will also bring out blue in the image on the screen. When making color-

corrections, wear black or dark gray. While white won't change the *color* on your screen it will reflect light back and affect the appearance of the image on the monitor.

Once you have your monitor(s) set up in a room that won't add color or light to the image on your monitor, then you can complete the final step, which is to calibrate the monitor. There are many companies that make calibration software, and they all work in pretty much the same way, but it's best to use the same brand that your lab uses.

There are two methods that you can use to calibrate your monitor. Your first option is to have a photograph printed out through the print device you will be calibrating your monitor to. Next, you can pull up that same file on your monitor and change the color, contrast and lightness/darkness controls of your monitor to match the look of the print. This is simple and not very scientific, but it is a good starting point if it is all you have to work with.

The second option is a more popular method. It uses a monitor calibration device, like the Spyder® from ColorVision™. The Spyder and other devices like it consist of software and a device that sticks to your monitor with suction cups (don't use saliva to wet the suction cups!). As the program works, it goes through the various colors and runs tests until your monitor renders true color.

There's an important difference between the end results of each method discussed above: When you change the settings of your monitor to match the results of your printer, you are correcting the color to your output device. If you calibrate your monitor with a calibration device, it shows true color, which is necessary for using ICC profiles (I'll discuss this a little bit later).

You should calibrate your monitors at least once a month. As your monitors age, you'll need to calibrate them more often and, after a few years, you'll need to get new monitors. As they age, you'll find it impossible to keep the monitors calibrated.

Most photographers planning to get into digital think a digital camera and the latest version of Photoshop is all they need. It's obviously much more complex and expensive than that. The hardware/software I have discussed so far will get a photographer started, but there are countless programs and devices that can make your life as a digital photographer easier. It's all about time versus money.

You need to calibrate your monitors every two weeks when they are new. As they age, you will need to do this more often. Use the same calibration device that your lab uses to ensure the truest color.

SHOOTING DIGITAL

*J*ust capturing a digital image is a very simple thing to do, but doing it well is something else entirely. With digital, there's no more burning up the film and having the lab correct it in the print. Essentially, with digital, you *are* the lab, so if you want to say good-bye to your free time, and you want your staff to do the same, you can be the same sloppy photographer you've always been. No one was as relaxed as I was when it came to photographing on negative film. There were times I shot outdoors without a light meter! I figured, "400 speed film, open shade—$\frac{1}{125}$ at 5.6!" It isn't rocket science, right? Well, when you shoot with digital, sometimes it feels as though it is.

● *Achieving Consistency*

You're looking for one thing in capturing digital images: *consistency!* The more consistent your exposures are throughout a session, the less work you'll have when color correcting your images. The

The more consistent your exposures are throughout a session, the less work you'll have when color correcting your images.

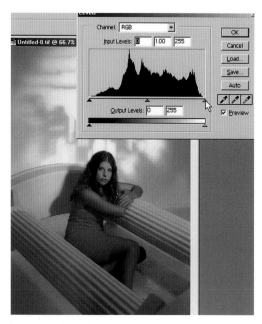

You have 256 tones in each channel of an RGB digital image, and you should consistently use as many of them as possible. The histogram tool will help you to digitally improve any exposure problems.

first tool used in achieving consistency is a histogram. If you're like I was when I used my first digital camera, I didn't even know what a histogram was—I certainly didn't know how to use it.

Using Histograms. A digital image in the RGB mode has 256 tones in each channel (R, G, and B). These channels combine to create the millions of colors found in any given photograph. A histogram is a graphic representation of the colors in a particular digital image. Most images will never record all 256 tones in each channel, but overall (in the composite channel), you're looking for a full histogram with readings extending from 8–10 on the shadow end to 240–250, on the highlight end. If you don't fill the histogram consistently you're going to have problems getting a consistent look throughout your packages. The software that comes with most professional digital cameras allows you to preview your image and check the distribution of color in the histogram. It can also be done on the camera—most have a histogram on the pop-up LCD display that can be seen immediately after previewing the image.

● *Good Color versus Consistent Color*

You have to remember that consistent color is more important than good color. An easy way to see how the different areas of your studio look digitally is to lay the original files (without any correction) out on a single 8x10 page, basically making a contact sheet. Once this

sheet is complete, print it out on photo paper using an inkjet printer. While the color and quality won't be the same as you get from your lab, you'll see differences in color, contrast and density in the images. If all the skin tones are the same, you're one lucky son of a gun. If you're like most of us portrait photographers, though, the skin tones are all over the place. Make notes about the corrections you need to make in each area. You can keep doing this until you're getting consistent skin tones. You might need to make two or three contact sheets before you get the results you're after, but you can accomplish this in a single day instead of waiting for prints to come back from your lab.

Don't plan to buy your digital camera on Monday and photograph sessions on Thursday.

Once you have a contact sheet in which all of the images look consistent, send off your contact sheet files to your lab. See how they're rendered by their printer. This will give you vital information about how to modify the way you shoot. You'll start to recognize proper skin tone in your camera's preview and in the histogram, but it will take time. Don't plan to buy your digital camera on Monday and photograph sessions on Thursday. You'll need to practice and work out all of the bugs before you start using it to photograph paying clients.

Preventing Color Casts
As I said earlier, throw away anything that causes a warming effect in the portraits. Warming filters, gold reflectors for outdoor photography—anything that causes the color not to record true must go. Color casts are much more obvious on digital than film so, again, make sure that walls near the subject are painted the same way in all of your shooting areas.

● *Achieving Consistency in Lighting*
The more you use digital, the easier it gets to produce images with a consistent appearance. With the many shooting areas that we have in our two studios, I thought I'd never get a consistent look when going from one area to another with a client, especially using all the different types of lighting that we do with our seniors.

If you have multiple shooting areas and use several brands of lights, try to place them uniformly throughout the studio, making each shooting area as close as possible to the same temperature of light. If you have four shooting areas and a mixture of lighting brands, find four same-brand lights and make those your main lights, because they'll have the greatest impact in correcting variations in the

Make sure everything

is as consistent as

possible from one

area to another.

skin tone. Use the remaining odd brand lights as accent lights for the hair or background.

Overhead lights and modeling lights that don't turn off when the flash fires can also cause inconsistent results in your portraits. Make sure everything is as consistent as possible from one area to another as well as within the individual shooting area itself. I always have my overhead lights off because I want to see what my lighting is doing. For some studios that isn't possible, so make sure the overhead light is at least consistent, so when you set the white balance it will account for the coloration of the light.

Outdoors, be sure to check the color balance frequently, because the color temperature/white balance will change as you move through different scenes.

Every photographer has a certain style when it comes to lighting a portrait. Some use flash to fill the shadows, some use a reflector. One

This Page and Opposite: Once you have a contact sheet in which all of the images look consistent, send the contact sheet files to your lab. See how they're rendered by your lab's printer. This will give you vital information about how to modify the way you shoot. You'll start to recognize proper skin tone in your camera's preview and in the histogram, but it will take time.

When we started using digital, we started to use flash to fill shadow, because it provided more consistency.

photographer prefers a large uncontrollable box, while another wants some type of louvers to gain more control over where the light will fall. Although digital doesn't require a certain type of lighting, we found that we needed to modify some of our lighting to improve the appearance of our digital images. I have always been one to use reflectors to fill shadow. When we started using digital, we started to use flash to fill shadow, because it provided more consistency.

Another consideration with digital is diffusion. With film, we diffuse 95 percent of our portraits, at least to some degree. As men-

tioned previously, with digital, we don't. With this in mind, we altered our lighting ratios from about 4:1 to approximately 3:1 (softening the light to compensate for the reduction in diffusion). The reason I say "approximately" is that the subject's facial structure and skin tone will determine the exact ratio. Many photographers believe that light is light, and that dark skin requires the same ratio of lighting as light skin does. Think about it: if you take a pure white ball and set up a lighting ratio that just allows you to see detail in the shadow, then replace the white ball with an 18 percent gray ball, won't the shadow appear darker, because the overall shade is darker? Of course!

Lighting considerations impact the way in which skin tone is rendered during each session. Make sure everything is as consistent as possible from one area to the next as well as within the individual shooting area itself.

In our head-and-shoulder and year-book shooting areas we use a 42-inch Starfish/Halo, seating the subject at a mylar-covered drafting table. This reflective surface produces large, beautiful catchlights and emphasizes the client's eye color.

● Head-and-Shoulder and Full-Length Shots

In the studio, even when I use film, I want to achieve a constant quality of lighting when I move from head-and-shoulder shots to full-length portraits. For head-and-shoulder images we use a 42-inch Starfish/Halo softbox with a reflector coming from underneath the subject. This "reflector" is actually a drafting table covered with silver mylar. The drafting table makes a great posing table because it's sturdy and you can raise or lower the angle of the tabletop to increase or decrease the amount of light being reflected toward the face.

While most of our studio lights are made by Photogenic, we often use a spotlight made by Balcar. The light quality produced by each of these brands differs from one to the other, and causes an inconsistent skin tone rendition from one shooting area to the next. There are various ways to correct this problem, as outlined in this chapter.

To achieve the same beautiful light in a full-length pose (where the lights must be farther from the subject), we use a 72-inch Starfish and replace the drafting table with a 30x40-inch light box. The light on the floor reads approximately a stop and a half less than the main light.

I love the look of having a light coming from under the client . . .

To achieve the same quality of lighting in a full-length pose, we basically have to do two things. One is increase the size of the light since it will have to be further from the subject. For the full-length areas, we use between a 52- and 72-inch Starfish to achieve the same quality of light in the full-length pose that the 42-inch provides in the head-and-shoulders shots. The 52-inch is used with small sets and chairs, while the 72-inch is used to light large sets, because the light needs to be farther away from the subject.

With full-lengths, we also replace the drafting table used in the head-and-shoulder images with a 30x40-inch light box that's placed on the floor. I love the look of having a light coming from under the client when working with seniors. It brings out more of the eye color, smooths the skin, softens the circles under the eyes and adds an overall fashionable look to the portrait. And yes, I leave the second catchlight in the eyes. Many older photographers think it's taboo to see more than one catchlight in each eye, however.

A good pose is the key to a beautiful portrait. When positioning the subject, make sure that you can produce a head-and-shoulder, ¾- or full-length shot from a single pose.

In addition to this traditional style of lighting, we also use a variety of spotlights, projection boxes and smaller louvered light boxes to practice what I call *corrective* lighting (which is discussed at length in my last book, *Corrective Lighting and Posing Techniques for Portrait Photographers* [also available from Amherst Media]). No matter what type of lighting you use, your goal is to produce a consistent skin tone throughout each individual session. Be prepared: the more styles of lighting you use, the more testing you'll need to do before you start working with your clients.

If you have multiple shooting areas and use several brands of lights, try to place them uniformly throughout the studio, making each shooting area as close as possible to the same temperature of light.

DIGITAL OUTDOORS

There are photographers who take outdoor pictures and those who create outdoor portraiture. For years, my employees have wondered why I train photographers to take studio portraits, but I take the outdoor portraits myself. I can train a photographer to shoot in the studio in about two years. I don't know if I'll live long enough to get someone fully trained to shoot outdoors, though. After my employees read my book, *Outdoor and Location Portrait Photography* (also available through Amherst Media), they realize how much goes into creating beautiful outdoor portraits.

I can't count the number of times I've watched photographers working with their clients outdoors. They pull out their portrait camera fitted with a normal lens and then attach their Vivitar 283 flash. If I told you to go into the studio and create a beautiful portrait and gave you an on-camera flash, would you look at me like I was crazy? If you wouldn't use an on-camera flash in the studio, why

Shooting beautiful outdoor portraits requires a great deal of skill. With digital, you'll have to put your knowledge of lighting to the test and, more often than not, you'll need to make a number of modifications.

would you use one outdoors? You don't create a beautiful outdoor portrait using what wedding photographers call fill flash. Wedding photographers trade off quality to meet certain time lines—portrait photographers don't have that excuse.

● *Outdoor Image Storage*

For the digital photographer, there are two major problems with shooting outdoors. First is the storage of the images. To be safe in the studio, we work tethered to the computer, and the downloaded image is safely stored in the computer and on the CompactFlash card. If you take a computer outdoors, you could, for lack of a better word, *trash* your computer. I don't know about your outdoor locations, but the ones I go to don't have nice flat spots to place a tripod and especially not a tripod with a laptop attached to it. I sometimes even get into the water. Of course, there's also a lack of power. While batteries will keep you going for a while, they won't last through several long sessions. You can buy a stack of batteries at $250 apiece, but that can get a little pricey! I just rely on the CompactFlash card in the camera. After the session, I take the CompactFlash card/Microdrive out and download the images to my laptop. I don't keep a bunch of

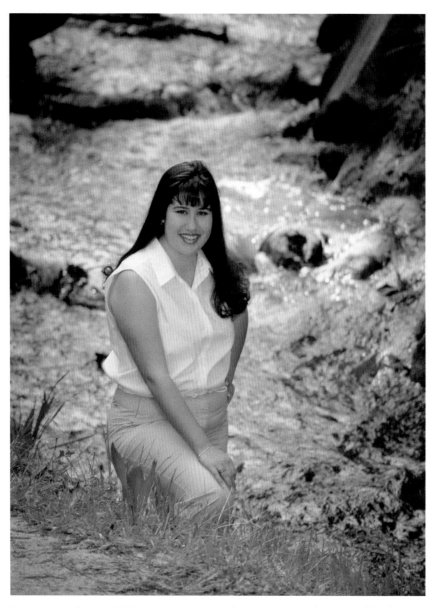

batteries—instead, I use a converter that generates household current from a car's cigarette lighter. I purchased it at an electronics store for under $100 (a whole lot less than $250 per battery!).

Still, some photographers really want the security of working with the camera tethered to a computer. I've seen all kinds of homemade mount plates for the laptops to fit on the tripod. Velcro strips secure the laptop to the base. I've even seen photographers wiring heavy-duty batteries to power the camera and laptop for hours. The one limiting factor is the terrain that you must work in. If you work in a little garden behind your studio, or anywhere else where you have level ground, you can attach casters for additional ease and safety. This way, you won't have to risk having to pick up and move the heavy tripod.

To make outdoor sessions at the natural locations profitable, we schedule blocks of appointments in a single day. This way the cost of travel is divided between ten to fifteen clients, making outdoor sessions a very profitable thing for the studio. We label a CompactFlash card for each client. At the end of each session we download the images to the laptop. Then we store the CompactFlash card in a safe place with the client's name on it. Again, this is good insurance against having to reshoot a client's session.

With film, there are many outdoor scenes in which the light is perfect and, with the quality of high-speed medium format film, no modification is necessary. With digital, you'll need to work a little harder to make the lighting work.

The Elements vs. Your Gear

The final problem to consider is the moisture, dust and, in my case, sand from the beach that gets into your electronic equipment. I don't offer digital at the beach. The only time I take a digital camera to the beach is when I am putting together a brochure/mailer/book. After the session, I go through each area I can get to and blow it out with pressurized, canned air. Even regular outdoor locations can expose your equipment to heat, cold, dirt and so many other things that electronic equipment isn't supposed to endure. I know some photographers who shoot digital in the studio but use film outdoors. I can understand why.

Problems in Outdoor Lighting

Another problem outdoors is the lack of control you have over your lighting. Color temperature and white balance change dramatically from sunlight to shade. Trying to match skin tones with no set level of lighting is a challenge, to say the least. I've always been a strong advocate of using reflectors outdoors, reflecting light from a mirror through translucent scrims and, when using flash, using studio flash and light boxes. You can use any and all of these modifiers outdoors to achieve a consistent look in your outdoor portraits.

Low light is another limitation of working with digital outdoors. While your camera will allow you to work with an ASA of up to 1600 or more, the higher the ASA the poorer the image quality. A digital camera or digital back that will produce a 24x30-inch image in the studio might only produce an 11x14- or 16x20-inch image outdoors with the higher ASA setting. So you need to raise the level of light to a point that you can work with the same ASA setting that you use in the studio.

Whether you decide to use a studio flash, a reflector or to pass mirrored sunlight through a translucent panel, you need to accomplish two things. First, you'll need to raise the light levels on your subject and second, you must create beautiful catchlights in your subject's eyes. With film, there are many outdoor scenes in which the light is perfect and, with the quality of high-speed medium format film, no modification is necessary. With digital, the lighting in almost every scene must be modified.

We use two reflectors for the majority of work we do outdoors. One reflector brings in light from an elevated position, acting as a main light, and the other takes the place of the drafting table inside the studio—it reflects light from underneath the client. With the one

Before you ever try working with a silver reflector and direct sunlight, learn to feather the light. If you blast a client with a direct beam of light from a silver reflector you'll get an evil look and watery eyes.

Achieving a consistent skin tone outdoors i
always a challenge because light, and there
fore the color temperature you're dealing
with, changes as you move from place t
place. For the best results, always double
check your preview or histogram to ensur
that your shot will look great.

reflector as the main light, and one underneath the subject, the natural light works as your fill light. Again, we're going for consistency—consistency in skin tone as well as style—between the lighting in the studio and the lighting found/used outdoors. This type of lighting works for about 90 percent of our outdoor photography because we work with single subjects. We use both silver and white reflectors. White is best for a softer light when we're working close to the subject; we use silver when the light must travel a long distance or the light source being reflected is very soft, like the open sky.

While I don't want to rewrite a portion of my outdoor book here, this is important information: Before you ever try working with a silver reflector and direct sunlight, learn to feather the light. If you blast a client with a direct beam of light from a silver reflector you'll get an evil look and watery eyes. When you feather the light, you take the direct beam of light and place it right above the head of your subject. As you lower the beam of light closer to the subject, you'll see the illumination on the face and the catchlights in the eyes intensify.

Before you ever try working with a silver reflector and direct sunlight, learn to feather the light.

PRINTING

*I*f you think about the business system you use from image capture to delivery of the final images, you'll realize that most of the responsibility is in your film lab's hands. They take the film, process it, color correct it and produce some sort of previews that you can show to your clients. You take the negatives you need for your package, put them in an envelope and send them back to the lab. They card the negatives, retouch the negatives, do a final color correction, then spot and do any necessary artwork on the print, providing you with a quote for exactly how much it will cost. When you get the order, if there's anything about the work they've done that you don't like, you simply mark it *remake,* and they repeat the process until you're satisfied.

With film, labs provide us with many services—and I think most of us have taken them for granted, until now! With film, the lab charges you for these services, but the charge is always negotiable. Switching to digital, you'll take over most of the

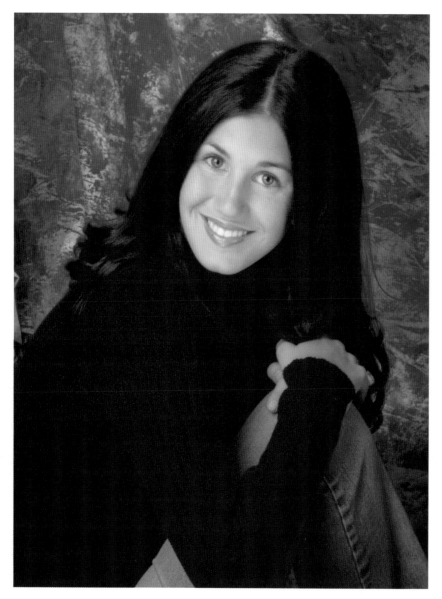

work. Your employee's mood and how talkative he or she is on any given day will affect your production schedule. Also, since you're now doing everything short of hitting the Print button, you can forget about the word *remake*. In the digital world, there's no lab to remake a print that wasn't retouched properly. If the image is too blue, too yellow, too whatever, the cost of the correction is on you.

Here's an excellent example of how your responsibilities change when you go digital. My lab offered me the same price on dance/prom units (under $1.60 a unit) on digital images that they did for film. At first, I was excited. I thought about the control I'd have over the pose that was selected, the cropping and the possibility of fixing problems that would be impossible with film. I was thinking like a photographer, which from a business standpoint is just about the worst thing you can do! After I thought about it for a while, I real-

ized that with film, I just finish the dance, send in the film and the next time I see it, it's printed and ready to package. The lab does a lot of the work.

This leads us to the first thing you must understand about labs—they're making a lot more money with digital than with film. With film, all of the "hands-on" labor that labs produced cut into their profits. With digital, photographers take over the bulk of the work that the lab didn't make any money on anyway, and the lab is still nice enough to charge you the same price that you'd pay for all of their film services. This adds to the final cost of the printing, and for what?

I suggest you work with a lab that does final color corrections while you're getting into digital and then, as you become more familiar with it, look to a lab that offers cheaper unit printing, and do the color correction and packaging yourself.

If you're doing everything "in studio" (which means your lab has one job—to hit Print), you should be paying prices that are close to those paid for dance/prom portraits captured on film. Your lab has no testing and no waste—and they don't have to worry about remaking anything. If your lab does final color corrections and allows remakes for bad skin tone, then you should only pay the same price as package printing from film, because again, they're providing the same service. I don't care how much their printer cost them. I don't care how super duper it is; all I care about is the bottom line, how much money I am going to put into my pocket, rather than the lab's.

Now, more than ever, you need to shop around. The lab you've always used for film might not be the best choice for your digital printing. Some film labs want to charge a premium price to simply

Don't images like these deserve first-class printing? Never use your inkjet printer to produce the final images for your clients. Such prints are not photographs; the image scratches off very easily and the color will change with exposure to light.

print digital files because it's a "new" thing and they think they can. At the same time, many digital labs are working as service bureaus, offering lower prices and few services. The choice is yours, but choose wisely. I suggest you work with a lab that does final color corrections while you're getting into digital and then, as you become more familiar with it, look to a lab that offers cheaper unit printing, and do the color correction and packaging yourself.

● *Printers*

Inkjet Printers. As photographers move into digital, there will always be one or two that look to cut corners, not by being frugal, but by being cheap (and there *is* a difference!). "Why pay a lab to print out photographs, I have an inkjet and photo paper! I'll print them myself!" No! Let me say it again—*no!* We're selling a product, one that's very important to our clients, who expect the finished product to last a lifetime. I use my inkjet to produce quick yearbook prints and, occasionally, to produce publication photos when there's no time to send a file to the lab. Whatever you do, though, never use an inkjet to print out portraits that you'll sell to a client. I know it's easy, and I know that it's cheap, but these prints are not photographs. The image scratches off very easily and the color will change with exposure to light. (A photograph will change too, but not as quickly.)

Dye-Sub Printers. Many photographers that like the idea of printing their own work have looked to a dye-sub printer, which produces a better quality print than an inkjet printer. Two problems with dye-subs are that they're slow and the cost per unit is high. Although the output prices have come down, dye-sub prints are still more expensive than the unit printing offered by most labs. When you consider the slow operation and initial cost of the unit, it probably isn't the best choice for a portrait studio. (When shooting point-of-purchase type images [Santa/holiday pictures, event photos at shows, tournaments, etc.] dye-subs are vital because prints are needed the same day.)

Labs. This leaves the printers that quality labs use. They are expensive, but they produce a digital image on photographic paper, so you have the best of both worlds. This type of digital print not only looks like a photograph, but also feels like a photograph. The feel of a portrait is more important to the client than most photographers think. They want what they've always had, and they should. Why should your clients have to accept a product that's different or substandard, just because you made the decision to switch to digital? They shouldn't!

Whatever you do, though, never use an inkjet to print out portraits that you'll sell to a client.

Most photographers will find themselves sending their work to a lab. Any digital lab will provide what is called an ICC profile of their printer. This profile basically creates a filter that goes over an image as you view it, to give you a preview of the way their printer is going to print that image. This way, you can color correct your image and know that your photograph should look as it does on the monitor. ICC profiles are a must if you're sending your work to a lab that doesn't offer final color correction because otherwise you'll have no idea how their printer will print the image you're viewing. ICC profiles can be set up for any printer device you're using, from dyesubs to inkjets. They take the guesswork out of color management.

● *Preparing Your Images for the Lab*
One of the biggest problems facing digital photographers is that we aren't the only ones who are learning a new way of doing things. Labs are diving into digital too, and they have problems to work through just like we do.

As I mentioned earlier, I realized that the labs haven't yet figured it all out when mine offered to print my digital and film images at the same price. I asked about preparing the packages for the lab and identifying the packages once the dance arrives. With film, we have negatives to track the order and, with the numbering on the negative, we can identify the name of each couple. I asked the owner of the lab, "How do we track who's in each package with digital?" I wanted to know how we were supposed to identify each couple without popping in the CD and running back and forth between the computer and the production table. His response was, "I don't know!"

His response caught me off guard. This is a man who usually gives me too much information when I ask him a question, but he didn't know how to effectively identify the dance units. He said that I'd have to pull up each file to match it to the printed unit and then get the name off the file. Talk about taking a job that's time-consuming and making it impossible! I thought about it while we were on the phone and came up with a solution. I told him the only way this would work is if the files on the CD were limited to a specific number and an 8x10-inch page was printed with each file on it (like a contact sheet). I figured that we could have the file name imprinted on each photo (this is done in ImageBook™, a program we'll discuss in chapter 8). He agreed that this was a good idea, that it'd speed up the production of the dance package. He said he'd even print this 8x10-inch image at no charge.

Most photographers will find themselves sending their work to a lab.

While you can use a dye-sub printer to print your own images, your clients really do expect their images to be printed on high-quality photographic paper. While having your lab print the images will cost more, your clients are sure to appreciate the way their photos look and feel—and pleasing your clients is what it's all about.

In working with a lab, take their learning curve into consideration. Prepare and send your work to the lab in a way that best suits your workflow.

Our lab wants each file to be packaged as a unit, done with Packagizer software. They want each file name on the CD to include the print size (Johnson0126-4x5, Johnson0126-5x7, etc.). Once we burn the CD, they want a printed list of the file names and sizes so they can quickly make sure the order is complete without having to check the files on the CD. These are the lab's requests—they make their work easier, but not ours. We found that we had to enter into an area that we weren't familiar with. We had to package, set up lithos and templates (which have names and schools/school years that could be misspelled!) and make sure we weren't missing a unit out of a package. When we first started, we'd have to send in some orders twice to get everything in the package complete. For this reason, we made the person who writes up the orders for the lab responsible for

checking each CD before it goes to the lab. Quality control saves time and money. When we first started packaging digital, there were misspelled names or school years that weren't changed from what was on the original template—all kinds of mistakes that cost the studio time and money. With a responsible person to check over each order, mistakes seldom happen.

With properly labeled files and a backup CD, you can easily locate any images that your client may want reprinted in the future.

We put each client's order on a separate CD. This simplifies filing and retrieval if there's a problem. I know photographers who burn multiple orders on a single CD to save money, but again, this makes the identification of each person impossible without loading the images onto a computer. With savings in mind, some photographers use rewritable CDs or some other form of reusable disk/drive (Zips/Jaz™, etc). If these options are working for you, that's fine, but I like a permanent record that can't be altered or accidentally overwritten.

As I said before, we burn two CDs after each session is over. One CD is for the regular file, the other is a backup copy to be stored in the computer area (darkroom). Once the order is packaged we burn two CDs of it; one goes to the lab and the backup copy is for the client's file. Once we do this we can delete the client's folder from

our hard drive. If you aren't currently using digital, you'll be amazed by how fast a 40, 60 or 100G hard drive will fill up with your client's images. Remember, the more information stored on your computer, the slower it will run. The slower it runs, the more it costs your studio.

Developing a system for routinely getting unnecessary files out of your computer is a must. Depending on how you set up your computers, you need to delete files that have been backed up on CD daily. Orders can't remain in your computer for the two to four weeks it takes for delivery. Some frugal photographers may think we burn a lot of CDs. At less than $.30 apiece, though, they're an inexpensive way to safeguard your client's files and keep your computer running as quickly as possible.

We send a CD containing each order to our lab through a shipping company, and our lab picks up the tab. Some photographers send their images over the Internet to avoid shipping costs and to speed up the return of their work. That option works if you have a DSL or cable hookup, and it's running at a high enough speed. We had a cable modem installed and we spent the majority of the time waiting for it to work and when it did, it was only fast in the wee hours of the morning.

In time, both cable and DSL will improve, becoming cheaper and more predictable in their speed, which will provide photographers a way to get work to the lab as quickly as possible. But again, don't set up Internet service for your studio computers. To ensure that no one will cause a problem at the studio, all the phones lines go through our phone system, which makes it very difficult for the average employee to hook up to a service provider. I have Internet service at home only and do all my work on the Internet there to avoid possible problems.

Developing a system of routinely getting unnecessary files out of your computer is a must.

PROFITING FROM DIGITAL

*I*f you aren't currently using digital, you're probably getting the feeling that there's much more work involved in digital than with film—and you're absolutely correct. So, why would you go through all that extra work if you didn't see the opportunity for additional profit? When most photographers make the change to digital, they basically do exactly what they've always done with film. If you conduct your business in the exact same way, why would you want to incur the extra expense and work? Because of the lure of technology. We photographers are gadget freaks. We like to have an arsenal of toys and there's no bigger toy on the market right now than the digital camera and the support system that goes with it. We all know the artistic possibilities of digital, but few people have figured out how to make the additional profit to cover those new expenses. If you make the switch to digital without formulating a clear plan to increase your profit line, you'll have less free time

and less profit than you ever did with film—and you'll be in over your head after just one year.

After we made the decision to start offering digital sessions, we had the digital rep from our lab come to our studio to help in the transition. As we were going over the basics of how we'd configure the computers, handle the client files etc., he asked me how we were going to show our clients the previews of their sessions. I explained that we'd show the clients their images and have them order immediately following their sessions. He looked at me with one raised eyebrow and explained that most photographers send in the files to have proofs made for clients. I told him that was exactly why I was going to show the previews after the session. When it comes to raising your profit, take at look at what the average photographer is doing, then do something else. Why? Because many photographers would rather live in near poverty than learn to become more than what they are.

As the conversation continued, I asked him, "How would I pay for all the additional costs I've incurred with the switch to digital if I did everything the same as with film?" A better question is, if I was going to have to shell out big bucks for the equipment, invest more of my own and my staff's time, why would I switch to digital if there was no additional profit to make that switch worthwhile?

When I first opened my studio we showed family portraits on "Trans-Vues," which were 35mm slides formatted to fit the composition of the film you used. When we shot with Hasselblad, they came in a square, and when we switched to 645 they were rectangular. We had a long, narrow living room setting and hung a 40x60-inch frame with a piece of white foam core inside mounted over the sofa. I'd show each pose in this 40x60-inch size. Since the projector had a zoom lens, we could go down three sizes. The idea was that they got used to seeing the portrait in the 40x60 size and anything smaller just seemed "small." This simple sales technique helped sell larger wall portraits and raised our profits from each session. Without this type of selling, I never would've made it through those first few lean years when I opened my studio.

Additional sales were made because the slides didn't leave the studio. The first time a client saw the portraits they'd become excited—and that excitement resulted in larger sales. Let's be honest—it's photographers, not clients, who've kept paper proofs around for so long. Ever since I entered into professional photography, I've heard photographers talking about the huge sales that were possible when all of the previewing was done in the studio. Instant previewing is one of

The best sales are made when the client is still excited about the session. You're likely to get a better response to the various images you show the client when all of the previewing is done in the studio.

the only reasons why many mall photographers/corporate studios are able to sell photos. People look at their photographs for the first time and place their orders. We have an emotional product and that prod-uct sells best when a client is still emotional about it.

I think photographers have kept paper proofs around because the method is nonconfrontational. When you (or a studio staff member) show the images after a session, there's some risk involved, a risk of rejection. The client could look at those portraits and say they're the ugliest images they've ever seen. He or she could say they could've done a better job with their own digital camera at home. The feelings photographers experience after hearing comments like this make them fearful of selling, and that's why so many still use paper proofs.

How many times have photographers looked at a session, realized they did less than their best job shooting it and, rather than con-fronting the client about reshooting, just take the proofs, seal the envelope and hand them to the client? They only hope that the client will wait until they get home to open them so they don't have to deal with any problems in person. I know other photographers who mail proofs directly to their clients' homes. Talk about shooting yourself in the foot—they have no chance to sell anything! They're relying on the quality of their images and a client who, like all of us, loves to put things off. They want to take time to read and understand a confus-ing price list, then have to make time to come into your studio to place an order. Some clients will order, but many clients will simply put it off and forget. Photographers who live in fear of dealing with a dissatisfied client *lose* sales. Overcoming that fear is the greatest achievement—it's one of the best steps a photographer can take.

The availability of another client favorite—digital proofs on CD—also stems from photographers who hate selling. When photogra-phers send these image-filled CDs home with clients, their fear of confrontation shows—and overwhelms their good business sense. In our studio, we don't make paper proofs, and we don't offer our clients CDs, either. If I'm going to go through all the extra work and absorb the added costs that are involved with digital, I'm going to be well paid for it. If I don't increase my profit, I'll lose money by shoot-ing a session with digital as opposed to film.

Working with digital gives us the perfect opportunity to have the client make a purchase right after the session. If a client asks for proofs, you can explain that when everyone used negative film a pho-tograph had to be made for a client to see the image. With digital, you can see the image immediately, so a photograph is unnecessary.

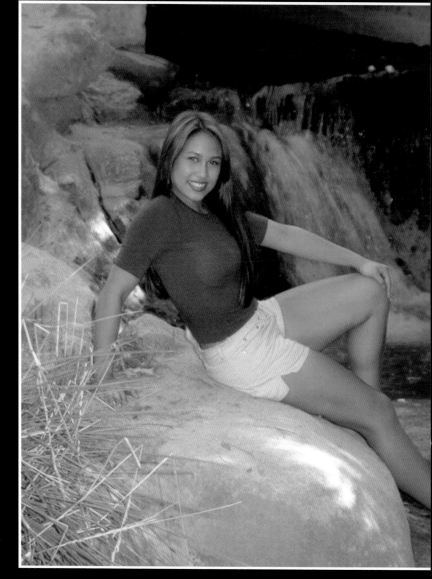

At our studio, the sales average achieved by digital sessions is twice that produced with film. Since no previews leave the studio, 100 percent of our orders from digital sessions come from our in-studio previews.

A great follow-up to that statement is, "this is why we can have so many images to choose from in a digital session. This would be impossible with film because of the cost."

Selling after the session works in our studio for a number of reasons. First, we explain to each client, right from the beginning, what a digital session is. We explain that digital makes it possible to offer additional clothing changes, add special effects and use templates. We also explain that they'll be viewing and ordering from the previews after the session is over.

At our studio, the sales average achieved by digital sessions is twice that produced with film. Since no previews leave the studio, 100 percent of our orders from digital sessions come from our in-studio preview sessions. With film sessions, on the other hand, a good number of clients' names are given to collection agencies. Why? Because they never returned their costly take-home proofs. Taking this risk not only reduces the average sale, it also ensures that we won't get any business from younger siblings when they need senior portraits.

At our studio, the sales average achieved by digital sessions is twice that produced with film.

Keeping Your Clients Informed

Since we only photograph seniors, we require that they bring along a parent to help them select their package. Our policy is explained during our first telephone contact with the senior/parent, as well as in our mailer, which outlines must-have information such as the date and time of their appointment and the length of time they'll be at the studio.

● *Selling Portraits After the Session*

When selling portraits immediately after the session, you invest more time in the whole digital process, but it is time well spent. To make the selling process run smoothly, you'll need to develop a logical way to guide your clients through the buying process. They will need to understand what they should do through each step of the procedure.

We have taken the same sales system we used with families (Trans-Vues projected into an empty frame) and modified it to work with digital. At our studio, we first sell the pose, then the size. To make this work, you need two things: the largest monitor you can afford and a program that will allow you to quickly display all of the images and the image names/numbers, making the image selection process easy both for you and for your client.

We use a 21-inch monitor for showing our images. Although I'd like to use a digital projector and have preview rooms set up like we

used to for families, with our volume that would be impossible. We use a program called ImageBook that allows us to set up 16x20-inch "pages" and stamp each image with its file name so we can easily record a client's favorite selections.

We take about forty digital images (we shoot five photos for each of eight distinct backgrounds/poses). When it is time for the client to view the images, we open each file. For each image group, we decide which of the five images is best. This narrows forty images down to eight. Eight is the ideal number for us, because we sell so many folios, which have eight openings.

While the employee at the computer is pulling up the single files, a salesperson takes the clients to a private sales area, explains the packages and helps the client decide on the one that's right for them. Since we can't show their portraits in wall portrait sizes on the monitors, sample prints in various wall portrait sizes are hung in each sales area. Once they decide on the package, they are brought back into the computer salesroom. The computer person then simply fills the packages with the eight images that are on the screen.

We have divided the sales areas because of our volume. If someone is taking a long time to decide on a package, they aren't taking up time at the computers, so we can start with someone else. The average order takes about 45 minutes, but some clients take up to an hour and a half. We had one senior who brought in both her mom and stepmom, and they spent two and a half hours ordering. It was a long time, but the sale was over $1,500. Everything is measured in terms of time versus money. If someone has the money, I have the time!

Everything is measured in terms of time versus money. If someone has the money, I have the time!

● *Setting Up Your Viewing and Sales Stations*
Immediately following the session, the clients are brought to the preview area. Our goal here is to get them through this area quickly. We provide no seating in this area. Why? Because people make decisions faster when standing than when sitting. When someone is seated they want to relax and chat. When they're standing, they want the process to move along quickly so they can sit.

When we get our clients into the preview room, the first thing we tell them is how easy it is to select the best pose; "There is always one image that's by far the best in each image group (pose/background combination)." This way they don't question themselves endlessly, thinking the decision is a hard one to make.

We do provide seating in the sales area, which is where the client will select their package. It takes more time for the client to figure out

which package they'll buy. We do ask that all of our clients make a list of all the people they'll be giving a portrait to before they come in for their session; we've found that it speeds up the process.

When the client has decided on a package, they return to the previewing room to put the individual poses into it. We have computers in some of our sales areas just in case we get backed up in the previewing room. We use the same 21-inch Nokia Trinitron monitor in each of our previewing and sales rooms.

● *Supportive Service*
Selling after the session only works if you take the appropriate steps and guide your client through the buying process. You're a professional. Your clients look to you for help in every aspect of taking the photographs. It's only natural for them to look to you and your staff to help them through the buying process as well.

Since professional photography is a higher ticket item than mall or department store photography, our clients need to know what to expect. Many photographers like to surprise clients with the price of their portraits, but it's better to prepare them for what's ahead. Inform your clients that they'll be viewing and selecting their portraits right after their session. Tell them that packages range in price from "X" to "Y," and that they'll need to put down your standard deposit to start an order. Once you've given your clients the information they need to make informed decisions, they'll find this type of selling very personal and much easier than taking proofs home (where they don't have professionals to help them). Every past client who has gone through this process after a digital session has told us that it was a pleasant experience, and the vast majority commented on how much easier it was than using proofs.

It's best to give your clients a price range for your work before they preview their images. That way, when they see that must-have image, they won't suffer from sticker shock!

GOING DIGITAL YOUR OWN WAY

Switching from film to digital is a very personal decision. While many people have made the switch, before you consider it, you have to know it's right for your studio at this time. If you're not sure you can swing it right now, wait. There isn't a time limit for making the change. As a matter of fact, each year, cameras are getting better and cheaper. With more professional photographers changing to digital, the support software and services available from labs are also improving and, in time, it will only get easier to make the transition.

In our situation, we can never make large changes to our business. With two studios that work with over 4,000 seniors a year, changes need to be well planned out. When I talked to my wife, Charla, about switching to digital, it was a hard sell. Charla likes shopping where she shops and traveling where we travel, so she wasn't in any hurry to change a system that was working very well the way it was. I completely agreed.

At our studio, we call digital sessions "premier sessions." When a client decides on a digital session, she knows that I will personally photograph the session, and that she'll get more images and clothing changes than in a film session.

● *Making Digital Work for You*

I had to think long and hard to come up with a way to make additional profit with digital that wasn't possible with just film. We talked about it and decided to incorporate digital into the studio slowly, expanding its use as our knowledge improved and our staff's training progressed. We decided to offer digital as our premier session—a session in which the senior's photographs were made by *me* rather than one of my staff photographers. We decided that in our digital sessions, we'd shoot more photographs and offer more clothing changes than in our film sessions and, of course, the sitting fee would be set higher to cover the additional expenses.

In the beginning, I averaged about two digital sessions a day, mixed in with all of my other film sessions. This was perfect. It not only allowed us the time we needed to learn how to properly handle

the clients and their files, but it also gave our lab time to work out their problems. After all, they were learning as they went, just as we were.

With film, we might have returned two prints a month for bad skin tone, but when we first started shooting digitally, our lab was working through the learning curve, too. We sent some orders back to the lab as many as four times before the skin tone was acceptable.

When you're getting started in digital, it's important to work with a lab that will do all of your color correction for you. Many labs offer unit printing under $1.75 a unit, but they print the file exactly as it is when you give it to them. Pay the extra dollar or two to a lab that will color correct your units, at least until you get used to working with digital.

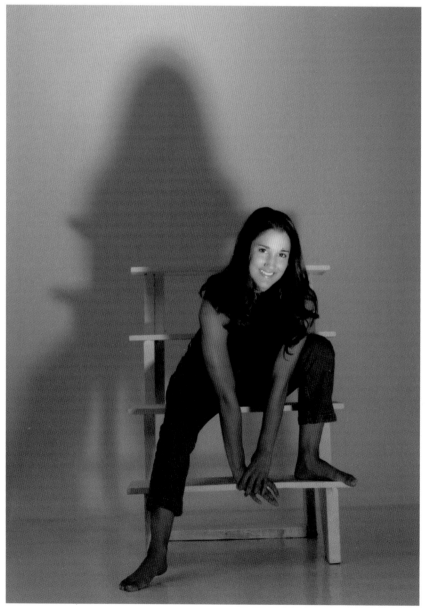

Your ability to sustain a profitable photography business will be determined less by the type of camera you use than by the knowledge you put into its use.

Most studios make leaps, rather than taking small steps to get where they want to be.

As time has gone on, we have offered more digital sessions and fewer film sessions. At this point, I don't know if we'll ever stop offering film sessions. Being a contracted studio, we work with all types of clients and, while the majority like the whole digital process, some clients still insist on proofs. If a client wants proofs, it's cheaper for the studio to shoot the session on film. Film is also cheaper to use for dances, proms, candids and groups taken for the schools—and whenever your client needs to see paper prints before making the final selection.

Many photographers look at converting from film to digital as an all or nothing change. Most studios make leaps, rather than taking small steps to get where they want to be. The greater the leap, the farther you can fall.

Our transition to digital has been pretty much painless. We've used digital as a tool to increase our profit and the quality of product we offer to our clients, without overwhelming the staff. We've been able to put together a business system that takes each digital file from capture to delivery . . . *profitably!*

● *In Conclusion*

Both digital and film have practical uses. Both can make you a great deal of money. It's a choice that you have to make by separating out the facts from the hype and, in some cases, overcoming the fear of change that most of us have to conquer to become successful at what we do. Because of digital, some photographers that are in business today will some day be out of business. But these photographers would have closed their doors with the first recession or increase in competition or just because they were tired of living in near poverty and didn't what to have to learn to become more than what they were. Digital will also make some photographers rich, because they'll see the potential of a new technology and take this profession to a new level.

In ten years, you won't see those flying cars; you won't see photographers out of work; you won't even see all professional studios using digital. You'll see men and women capturing images that they hope their clients will like. Those clients will still order prints that are copyrighted by their photographers. Those photographers will still pay their bills and, hopefully, have a big stack of money left over every month to invest in their future. Life goes on, and time and people change, but never as much as we think.

Your ability to sustain a profitable photography business will be determined less by the type of camera you use than by the knowledge you put into its use. The success you enjoy or dream of will be determined more by passion than knowledge. The key to *lasting* success is to never let your passion for photography become secondary to your knowledge or your responsibilities.

Your success in this profession will be determined by your knowledge and your passion, not the way you capture your images. A camera is a tool we use, not a toy or a barometer for what we can achieve.

My father had a saying as I was growing up. The older I get, the more meaning I see in his words. He said, "As long as a man thinks of himself as green, he is growing. It's only when he considers himself grown that he begins to die." With this, I wish you luck in your journeys.

RESOURCES

Adobe Systems Incorporated
Photoshop
www.adobe.com

Gamut Imaging
ImageBook
www.gamutimaging.com

Morris Grover's PhotoArt
plug-ins
(888) 263-2557

Pro Templates
templates
www.protemplates.com

Plug-In Systems
Packagizer
www.plugin.com

INDEX

Other Books from
Amherst Media

ALSO BY JEFF SMITH

Success in Portrait Photography
Marketing and Management Techniques for Studio Owners

No photographer goes into business expecting to fail, but many realize too late that camera skills alone do not ensure success. Studio owners must also run savvy marketing campaigns, attract clients and provide top-notch customer service. This book provides the instruction and inspiration needed to meet all of your professional, financial and artistic goals. Beginning with attracting clients, Smith shows you how to develop your marketing strategy—*and* avoid common mistakes. You'll also learn how to set your prices, develop a realistic budget, reduce operating costs and more. $29.95 list, 8½x11, 128p, 100 full-color photos, order no. 1748.

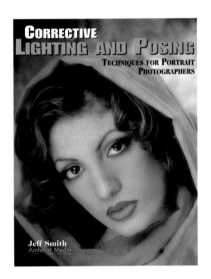

Corrective Lighting and Posing Techniques for Portrait Photographers

This complete, step-by-step guide focuses on the challenges of photographing the average client. Beginning with the consultation, Smith offers suggestions on how to tactfully address clients' problem areas. Smith teaches readers how to utilize special poses or suggest clothing that will downplay figure problems, double chins and more. Readers will also learn how simple refinements in positioning the main, fill and accent lights can result in dramatic improvements in their portraits. Posing for full-length and head-and-shoulders shots is covered in detail. Don't miss this must-have, timeless book. $29.95 list, 8½x11, 120p, full color, 150 photos, order no. 1711.

Outdoor and Location Portrait Photography
2nd Edition

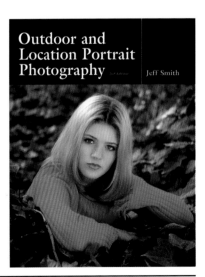

Outdoor portraiture offers photographers countless opportunities to create memorable images. In this book, you'll learn to select the best equipment, identify the perfect light, choose great settings and pose your subjects to create technically flawless, personality-filled images. In addition, you'll learn the customer service and marketing skills you need to increase your profits. Packed with inspiring photographs and hard-won tips to better your business, this book is perfect for beginners and advanced photographers alike. $29.95 list, 8½x11, 128p, 125 full-color photos, index, order no. 1632.

Basic 35mm Photo Guide, *5th Edition*

Craig Alesse

Great for beginning photographers! Designed to teach 35mm basics step-by-step—completely illustrated. Features the latest cameras. Includes: 35mm automatic, semi-automatic cameras, camera handling, f-stops, shutter speeds, and more! $12.95 list, 9x8, 112p, 178 photos, order no. 1051.

Big Bucks Selling Your Photography, *2nd Edition*

Cliff Hollenbeck

A completely updated photo business package. Includes starting up, getting pricing, creating successful portfolios and using the internet as a tool! Features setting financial, marketing and creative goals. Organize your business planning, bookkeeping, and taxes. $17.95 list, 8½x11, 128p, 30 photos, b&w, order no. 1177.

Infrared Landscape Photography

Todd Damiano

Landscapes shot with infrared can become breathtaking and ghostly images. The author analyzes over fifty of his compelling photographs to teach you the techniques you need to capture landscapes with infrared. $29.95 list, 8½x11, 120p, 60 b&w photos, index, order no. 1636.

How to Operate a Successful Photo Portrait Studio

John Giolas

Combines photographic techniques with practical business information to create a complete guide book for anyone interested in developing a portrait photography business (or improving an existing business). $29.95 list, 8½x11, 120p, 120 photos, index, order no. 1579.

Fashion Model Photography

Billy Pegram

For the photographer interested in shooting commercial model assignments, or working with models to create portfolios. Includes techniques for dramatic composition, posing, selection of clothing, and more! $29.95 list, 8½x11, 120p, 58 photos, index, order no. 1640.

Black & White Portrait Photography

Helen T. Boursier

Make money with b&w portrait photography. Learn from top b&w shooters! Studio and location techniques, with tips on preparing your subjects, selecting settings and wardrobe, lab techniques, and more! $29.95 list, 8½x11, 128p, 130+ photos, index, order no. 1626.

Stock Photography

Ulrike Welsh

This book provides an inside look at the business of stock photography. Explore photographic techniques and business methods that will lead to success shooting stock photos—creating both excellent images and business opportunities. $29.95 list, 8½x11, 120p, 58 photos, index, order no. 1634.

Profitable Portrait Photography

Roger Berg

A step-by-step guide to making money in portrait photography. Combines information on portrait photography with detailed business plans to form a comprehensive manual for starting or improving your business. $29.95 list, 8½x11, 104p, 100 photos, index, order no. 1570.

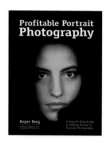

Professional Secrets for Photographing Children *2nd Edition*

Douglas Allen Box

Covers every aspect of photographing children on location and in the studio. Prepare children and parents for the shoot, select the right clothes capture a child's personality, and shoot storybook themes. $29.95 list, 8½x11, 128p, 80 full-color photos, index, order no. 1635.

Handcoloring Photographs Step by Step

Sandra Laird & Carey Chambers

Learn to handcolor photographs step-by-step with the new standard in handcoloring reference books. Covers a variety of coloring media and techniques with plenty of colorful photographic examples. $29.95 list, 8½x11, 112p, 100+ color and b&w photos, order no. 1543.

Family Portrait Photography

Helen Boursier

Learn from professionals how to operate a successful portrait studio. Includes: marketing family portraits, advertising, working with clients, posing, lighting, and selection of equipment. Includes images from a variety of top portrait shooters. $29.95 list, 8½x11, 120p, 123 photos, index, order no. 1629.

Photographer's Guide to Polaroid Transfer, *2nd Edition*

Christopher Grey

Step-by-step instructions make it easy to master Polaroid transfer and emulsion lift-off techniques and add new dimensions to your photographic imaging. Fully illustrated to ensure great results the first time! $29.95 list, 8½x11, 128p, 50 full-color photos, order no. 1653.

Black & White Landscape Photography

John Collett and David Collett

Master the art of b&w landscape photography. Includes: selecting equipment (cameras, lenses, filters, etc.) for landscape photography, shooting in the field, using the Zone System, and printing your images for professional results. $29.95 list, 8½x11, 128p, 80 b&w photos, order no. 1654.

Wedding Photojournalism

Andy Marcus

Learn the art of creating dramatic unposed wedding portraits. Working through the wedding from start to finish you'll learn where to be, what to look for and how to capture it on film. A hot technique for contemporary wedding albums! $29.95 list, 8½x11, 128p, b&w, over 50 photos, order no. 1656.

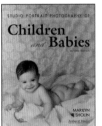

Studio Portrait Photography of Children and Babies, *2nd Edition*

Marilyn Sholin

Work with the youngest portrait clients to create cherished images. Includes tips for working with kids at every developmental stage, from infant to preschooler. Features: lighting, posing and much more! $29.95 list, 8½x11, 128p, 90 full-color photos, order no. 1657.

Professional Secrets of Wedding Photography *2nd Edition*

Douglas Allen Box

Over fifty top-quality portraits are individually analyzed to teach you the art of professional wedding portraiture. Lighting diagrams, posing information and technical specs are included for every image. $29.95 list, 8½x11, 128p, 60 full-color photos, order no. 1658.

Photo Retouching with Adobe® Photoshop® *2nd Edition*

Gwen Lute

Designed for photographers, this manual teaches every phase of the process, from scanning to final output. Learn to restore damaged photos, correct imperfections, create realistic composite images and correct for dazzling color. $29.95 list, 8½x11, 120p, 60+ photos, order no. 1660.

Studio Portrait Photography in Black & White

David Derex

From concept to presentation, you'll learn how to select clothes, create beautiful lighting, prop and pose top-quality black & white portraits in the studio. $29.95 list, 8½x11, 128p, 70 photos, order no. 1689.

Marketing and Selling Black & White Portrait Photography

Helen T. Boursier

A complete manual for adding b&w portraits to the products you offer clients (or offering exclusively b&w photography). Learn how to attract clients and deliver the portraits that will keep them coming back. $29.95 list, 8½x11, 128p, 50+ photos, order no. 1677.

Posing and Lighting Techniques for Studio Portrait Photography

J. J. Allen

Master the skills you need to create beautiful lighting for portraits of any subject. Posing techniques for flattering, classic images help turn every portrait into a work of art. $29.95 list, 8½x11, 120p, 125 full-color photos, order no. 1697.

Watercolor Portrait Photography
THE ART OF POLAROID SX-70 MANIPULATION

Helen T. Boursier

Create one-of-a-kind images with this surprisingly easy artistic technique. $29.95 list, 8½x11, 128p, 200+ color photos, order no. 1698.

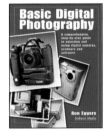

Basic Digital Photography

Ron Eggers

Step-by-step text and clear explanations teach you how to select and use all types of digital cameras. Learn all the basics with no-nonsense, easy to follow text designed to bring even true novices up to speed quickly and easily. $17.95 list, 8½x11, 80p, 40 b&w photos, order no. 1701.

Make-up Techniques for Photography

Cliff Hollenbeck

Step-by-step text paired with photo illustrations teach you the art of photographic make-up. Learn to make every portrait subject look his or her best with great styling techniques for black & white or color photography. $29.95 list, 8½x11, 120p, 80 full-color photos, order no. 1704.

Professional Secrets of Natural Light Portrait Photography

Douglas Allen Box

Learn to utilize natural light to create inexpensive and hassle-free portraiture. Beautifully illustrated with detailed instructions on equipment, setting selection and posing. $29.95 list, 8½x11, 128p, 80 full-color photos, order no. 1706.

Portrait Photographer's Handbook

Bill Hurter

Bill Hurter has compiled a step-by-step guide to portraiture that easily leads the reader through all phases of portrait photography. This book will be an asset to experienced photographers and beginners alike. $29.95 list, 8½x11, 128p, full color, 60 photos, order no. 1708.

Basic Scanning Guide For Photographers and Other Creative Types

Rob Sheppard

This how-to manual is an easy-to-read, hands on workbook that offers practical knowledge of scanning. It also includes excellent sections on the mechanics of scanning and scanner selection. $17.95 list, 8½x11, 96p, 80 photos, order no. 1702.

Professional Marketing & Selling Techniques for Wedding Photographers

Jeff Hawkins and Kathleen Hawkins

Learn the business of successful wedding photography. Includes consultations, direct mail, print advertising, internet marketing and much more. $29.95 list, 8½x11, 128p, 80 photos, order no. 1712.

Wedding Photography
CREATIVE TECHNIQUES FOR LIGHTING AND POSING, *2nd Edition*

Rick Ferro

Creative techniques for lighting and posing wedding portraits that will set your work apart from the competition. Covers every phase of wedding photography. $29.95 list, 8½x11, 128p, full-color photos, index, order no. 1649.

Traditional Photographic Effects with Adobe® Photoshop®

Michelle Perkins and Paul Grant

Use Photoshop to enhance your photos with handcoloring, vignettes, soft focus and much more. Every technique contains step-by-step instructions for easy learning. $29.95 list, 8½x11, 128p, 150 photos, order no. 1721.

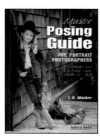

Master Posing Guide for Portrait Photographers

J. D. Wacker

Learn the techniques you need to pose single portrait subjects, couples and groups for studio or location portraits. Includes techniques for photographing weddings, teams, children, special events and much more. $29.95 list, 8½x11, 128p, 80 photos, order no. 1722.

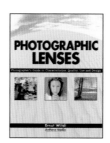

Photographic Lenses
PHOTOGRAPHER'S GUIDE TO CHARACTERISTICS, QUALITY, USE AND DESIGN

Ernst Wildi

Gain a complete understanding of the lenses through which all photographs are made—both on film and in digital photography. $29.95 list, 8½x11, 128p, 70 photos, order no. 1723.

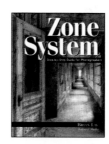

Zone System

Brian Lav

Learn to create perfectly exposed black & white negatives and top-quality prints. With this step-by-step guide, anyone can learn the Zone System and gain complete control of their black & white images! $29.95 list, 8½x11, 128p, 70 photos, order no. 1720.

The Art of Color Infrared Photography

Steven H. Begleiter

Color infrared photography will open the doors to an entirely new and exciting photographic world. This exhaustive book shows readers how to previsualize the scene and get the results they want. $29.95 list, 8½x11, 128p, 80 full-color photos, order no. 1728.

High Impact Portrait Photography

Lori Brystan

Learn how to create the high-end, fashion-inspired portraits your clients will love. Features posing, alternative processing and much more. $29.95 list, 8½x11, 128p, 60 full-color photos, order no. 1725.

Legal Handbook for Photographers

Bert P. Krages, Esq.

This book offers tangible examples that illustrate the *who, what, when, where* and *why* of permissible and problematic subject matter, putting photographers at ease to shoot—without fear of liability. $19.95 list, 8½x11, 128p, 40 b&w photos, order no. 1726.

The Art of Bridal Portrait Photography

Marty Seefer

Learn to give every client your best and create timeless images that are sure to become family heirlooms. Seefer takes readers through every step of the bridal shoot, ensuring flawless results. $29.95 list, 8½x11, 128p, 70 full-color photos, order no. 1730.

Photographer's Filter Handbook

Stan Sholik and Ron Eggers

Take control of your photography with the tips offered in this book! This comprehensive volume teaches readers how to color-balance images, correct contrast problems, create special effects and more. $29.95 list, 8½x11, 128p, 100 full-color photos, order no. 1731.

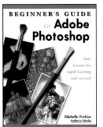

Beginner's Guide to Adobe® Photoshop®

Michelle Perkins

Learn the skills you need to effectively make your images look their best, create original artwork or add unique effects to almost any image. All topics are presented in short, easy-to-digest sections that will boost confidence and ensure outstanding images. $29.95 list, 8½x11, 128p, 150 full-color photos, order no. 1732.

Professional Techniques for Digital Wedding Photography

Jeff Hawkins and Kathleen Hawkins

From selecting the right equipment to building an efficient digital workflow, this book teaches how to best make digital tools and marketing techniques work for you. $29.95 list, 8½x11, 128p, 80 full-color photos, order no. 1735.

Lighting Techniques for High Key Portrait Photography

Norman Phillips

From studio to location shots, this book shows readers how to meet the challenges of high key portrait photography to produce images their clients will adore. $29.95 list, 8½x11, 128p, 100 full-color photos, order no. 1736.

Beginner's Guide to Digital Imaging

Rob Sheppard

Learn how to select and use digital technologies that will lend excitement and provide increased control over your images—whether you prefer digital capture or film photography. $29.95 list, 8½x11, 128p, 80 full-color photos, order no. 1738.

Professional Digital Photography

Dave Montizambert

From monitor calibration, to color balancing to creating advanced artistic effects, this book provides photographers skilled in basic digital imaging with the techniques they need to take their photography to the next level. $29.95 list, 8½x11, 128p, 120 full-color photos, order no. 1739.

Group Portrait Photographer's Handbook

Bill Hurter

With images by over twenty of the industry's top portrait photographers, this book offers timeless tips for composing, lighting and posing dynamic group portraits. $29.95 list, 8½x11, 128p, 120 full-color photos, order no. 1740.

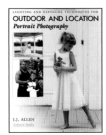

Lighting and Exposure Techniques for Outdoor and Location Portrait Photography

J. J. Allen

Teaches photographers to counterbalance the challenges of changing light and complex settings with techniques that help you achieve great images every time. $29.95 list, 8½x11, 128p, 150 full-color photos, order no. 1741.

Toning Techniques for Photographic Prints

Richard Newman

Whether you want to age an image, provide a shock of color, or lend archival stability to your black & white prints, the step-by-step instructions in this book will help you realize your creative vision. $29.95 list, 8½x11, 128p, 150 full-color/b&w photos, order no. 1742.

The Art and Business of High School Senior Portrait Photography

Ellie Vayo

Learn the techniques that have made Ellie Vayo's studio one of the most profitable senior portrait businesses in the United States. Covers advertising design, customer service skills, clothing selection, and more. $29.95 list, 8½x11, 128p, 100 full-color photos, order no. 1743.

Photo Salvage with Adobe® Photoshop®

Jack and Sue Drafahl

This indispensible book teaches you to digitally restore faded images, correct exposure and color balance problems and processing errors, eliminate scratches and much more. $29.95 list, 8½x11, 128p, 200 full-color photos, order no. 1751.

Photographer's Lighting Handbook

Lou Jacobs Jr.

Think you need a room full of expensive lighting equipment to get great shots? Think again. This book explains how light affects every subject you shoot and how, with a few simple techniques, you can produce the images you desire. $29.95 list, 8½x11, 128p, 130 full-color photos, order no. 1737.

Selecting and Using Classic Cameras

Michael Levy

Discover the charms and challenges of using classic cameras. Folders, TLRs, SLRs, Polaroids, rangefinders, spy cameras and more are included in this gem for classic camera lovers. $17.95 list, 6x9, 196p, 90 photos, order no. 1719.

The Art of Black & White Portrait Photography

Oscar Lozoya

Learn how master photographer Oscar Lozoya uses unique sets and engaging poses to create black & white portraits that are infused with drama. Includes lighting strategies, special shooting techniques and more. $29.95 list, 8½x11, 128p, 100 full-color photos, order no. 1746.

The Best of Wedding Photography

Bill Hurter

Learn how the top wedding photographers in the industry transform special moments into lasting romantic treasures with the posing, lighting, album design and customer service pointers found in this book. $29.95 list, 8½x11, 128p, 150 full-color photos, order no. 1747.

Photographing Children with Special Needs

Karen Dórame

This book explains the symptoms of spina bifida, autism, cerebral palsy and more, teaching photographers how to safely and effectively capture the unique personalities of these children. $29.95 list, 8½x11, 128p, 100 full-color photos, order no. 1749.

The Best of Children's Portrait Photography

Bill Hurter

See how award-winning photographers capture the magic of childhood. *Rangefinder* editor Bill Hurter draws upon the experience and work of top professional photographers, uncovering the creative and technical skills they use to create their magical portraits. $29.95 list, 8½x11, 128p, 150 full-color photos, order no. 1752.

The Best of Nature Photography

Jenni Bidner and Meleda Wegner

Have you ever wondered how legendary nature photographers like Jim Zuckerman and John Sexton create their captivating images? Follow in their footsteps as these and other top photographers capture the beauty and drama of nature on film. $29.95 list, 8½x11, 128p, 150 full-color photos, order no. 1744.

Beginner's Guide to Nature Photography

Cub Kahn

Whether you prefer a walk through a neighborhood park or a hike through the wilderness, the beauty of nature is ever present. Learn to create images that capture the scene as you remember it with the simple techniques found in this book. $14.95 list, 6x9, 96p, 70 full-color photos, order no. 1745.

Digital Imaging for the Underwater Photographer

Jack and Sue Drafahl

This book will teach readers how to improve their underwater images with digital imaging techniques. This book covers all the bases—from color balancing your monitor, to scanning, to output and storage. $39.95 list, 6x9, 224p, 80 color photos, order no. 1727.

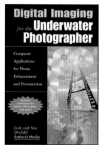

Photographers and Their Studios

CREATING AN EFFICIENT AND PROFITABLE WORKSPACE

Helen T. Boursier

Tour the studios of working professionals, and learn their creative solutions for common problems, as well as how they optimized their studios for maximum sales. $29.95 list, 8½x11, 128p, 100 photos, order no. 1713.